Mystical
MOODS OF IRELAND
Enchanted Celtic Skies

Volume I
Second Edition

Praise for James A. Truett's work...

"I look into your pictures and find that few minutes of peace and serenity each day. I thank you so much, you are a very bright spot in a very complicated world." **~ Sandra Morrison**

"Absolutely lovely. You have a true artists' eye, James ."
~ Mary O'Neill

"I am so glad that I happened upon your work. It is a beautiful and magical display of the Irish countryside. I plan on adding your complete collection to my library! Thank you for sharing the beauty that is Ireland and your wonderful talent with the world! I am a forever fan!!" **~ Marianne Moore**

"Your photos are like seeing poetry in living color..." **~ Candy Hardin**

"Your photos always make me smile, and I have to admit... daydream. Thank You So Much for sharing your gift with us that can only wish they had a talent. God Bless You!" **~ Heidi Mickey**

"Mystical vision... thank you Mr. Truett!!"
~ Linda Haggerty Walters Thompson

"I just love how your eyes are always open and catching the beauty of the world for the rest of us. Bless You, James."
~ Sue Ann Stannert Rivera

"You bring the magic of Ireland to all of us. Thank you!"
~ Jennifer Dudley Nelson

"You take me places I've always wanted to go. You make my dreams come true. Thank you, James." **~ Cheryl Phillips**

Mystical
MOODS OF IRELAND
Enchanted Celtic Skies

Volume I
Second Edition

James A. Truett

www.JamesTruettBooks.Com

TrueStar Publishing

UNITED STATES · IRELAND

Published by TrueStar Publishing
United States • Ireland
www.TrueStarPublishing.Com

Ordering Information:
All products in the Moods of Ireland series including books, calendars, posters, cards and prints are available at special quantity discounts for bulk purchases for sales promotions, premiums, fund raising, educational, corporate or institutional use. Specially customized books, calendars, posters, cards and prints can also be created to fit specific needs. For details, please e-mail the publisher at:
specialsales@truestarpublishing.com

ISBN: 978-1-948522-00-7

First Edition: September 2014
Second Edition: July 2015

10 9 8 7 6 5 4 3 2

Dedication

*For Lady Jane Cullinan
and the Cullinans and Murphys
of County Clare and County Kilkenny, Ireland*

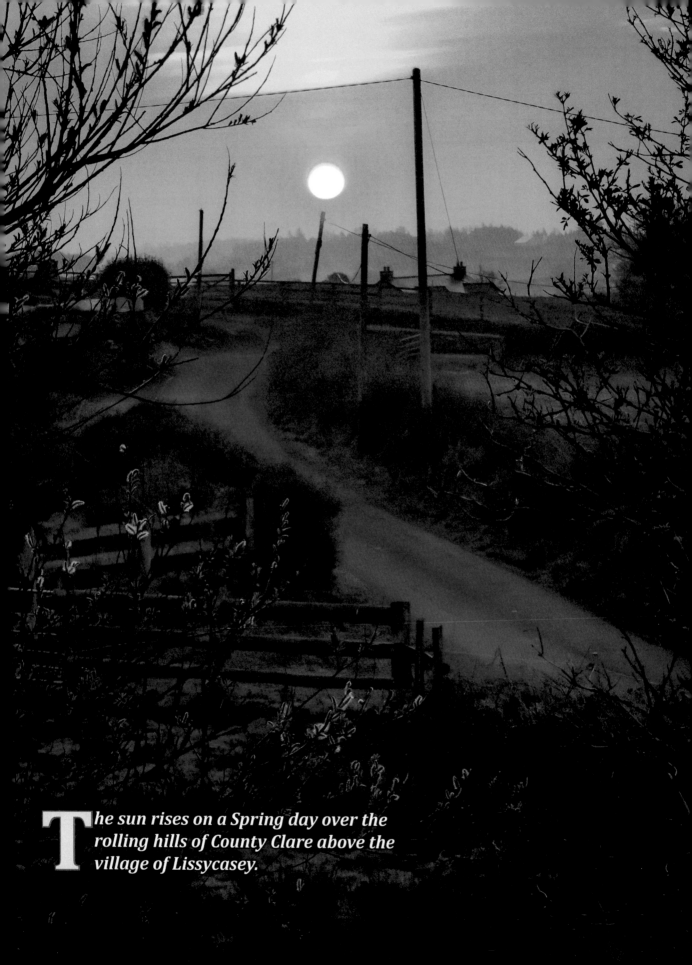

The sun rises on a Spring day over the rolling hills of County Clare above the village of Lissycasey.

Introduction
Skies: Window to the Celtic Soul

Perhaps the most common first impression visitors experience on arrival in Ireland has to do with the intensity of colors — flowers that ooze a soulful brightness and, of course, the brilliant green hills and meadows that have earned Ireland its nickname, The Emerald Isle.

It's nothing short of a "Wizard of Oz" experience — the classic film starts with lackluster black and white imagery, shifting to Technicolor when Dorothy lands in the mythical Land of Oz.

Along with the brilliance of color, most people also remark about the swiftly changing weather — it's not uncommon to experience four seasons in a day, sometimes several times over.

This book is the first in a series exploring the ever-changing skyscapes, landscapes and magic of the Irish countryside. Many of the images were taken from the same vantage point in County Clare, some on the same day and some only minutes apart.

As you view these pictures, I hope you will take a moment to soak up the color and experience the spiritual connection that has drawn so many to visit and reconnect with their ancestral roots as I have.

Cead mile failte! *(pronounced: "kade meela fall-cheh")*
A Hundred-Thousand Welcomes!

James A. Truett
County Clare, Ireland

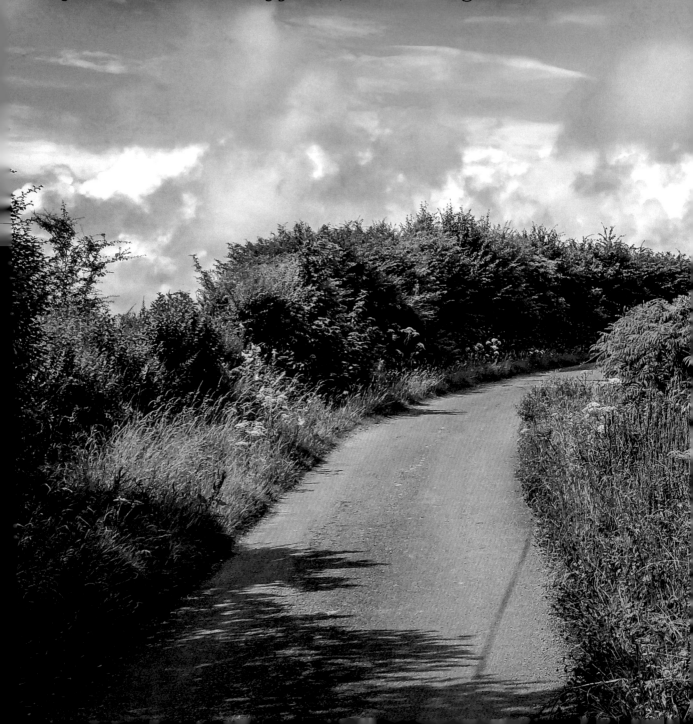

This road, in the hills above Lissycasey, County Clare, is a popular route for equestrians and hikers alike. The bright purple flowers are Foxglove, also known as "Fairy Thimbles," a biennial native of Ireland that generally blooms from June to August.

Ironically, this plant is poisonous — but it contains digitoxin and digoxin, both substances used in heart medications. In some parts of Ireland, they were considered unlucky flowers, not to be brought indoors.

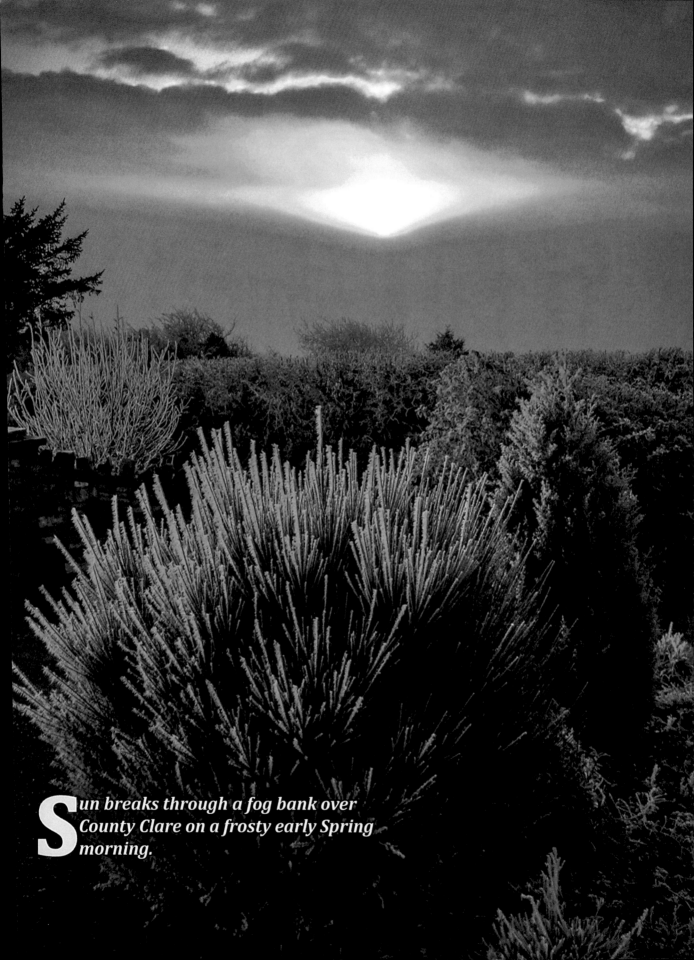

Sun breaks through a fog bank over County Clare on a frosty early Spring morning.

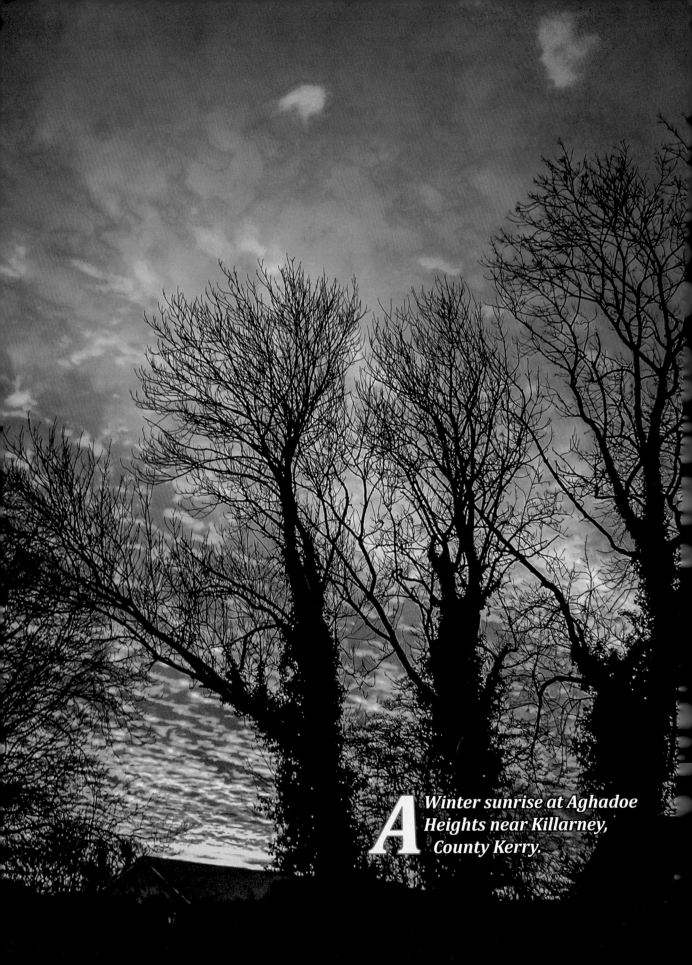

A Winter sunrise at Aghadoe Heights near Killarney, County Kerry.

Eurasian Magpies stand watch over the Irish sunrise in the enchanting County Clare countryside. These birds, part of the crow family, are recognized for their high level of intelligence and propensity for larcenous behavior.

Eurasian magpies not only are considered among the brightest birds on the planet, they're actually believed to be one of the smartest animals (humans included).

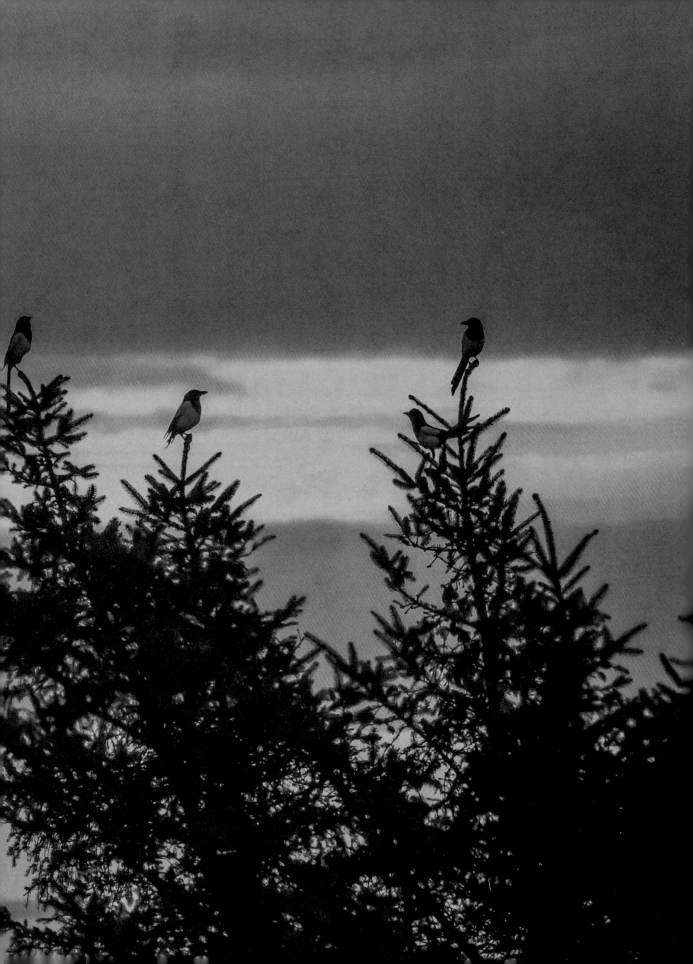

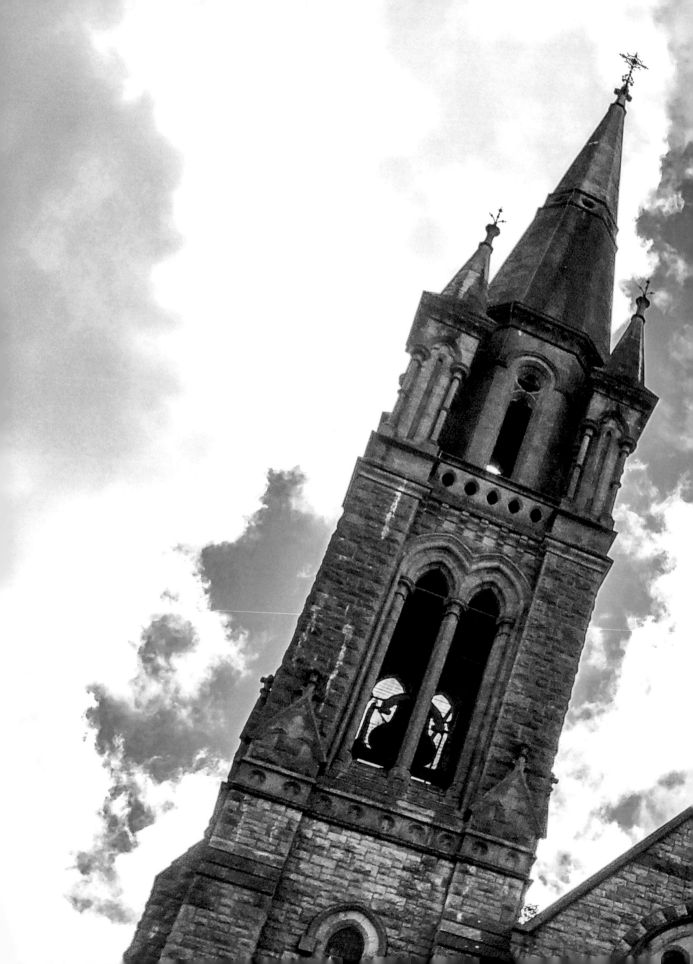

The steeple of Holy Cross Church is visible for miles in the skyline of Charleville, County Cork. The Gothic Revival Catholic church was built of local limestone over a period of four years starting in 1898 and was officially opened in 1902. The spire and belfry were finished in 1909.

The interior of the church is quite spectacular with its elegant stained glass, decorative mosaic, a massive restored organ in the gallery, and room for 1,000 parishioners.

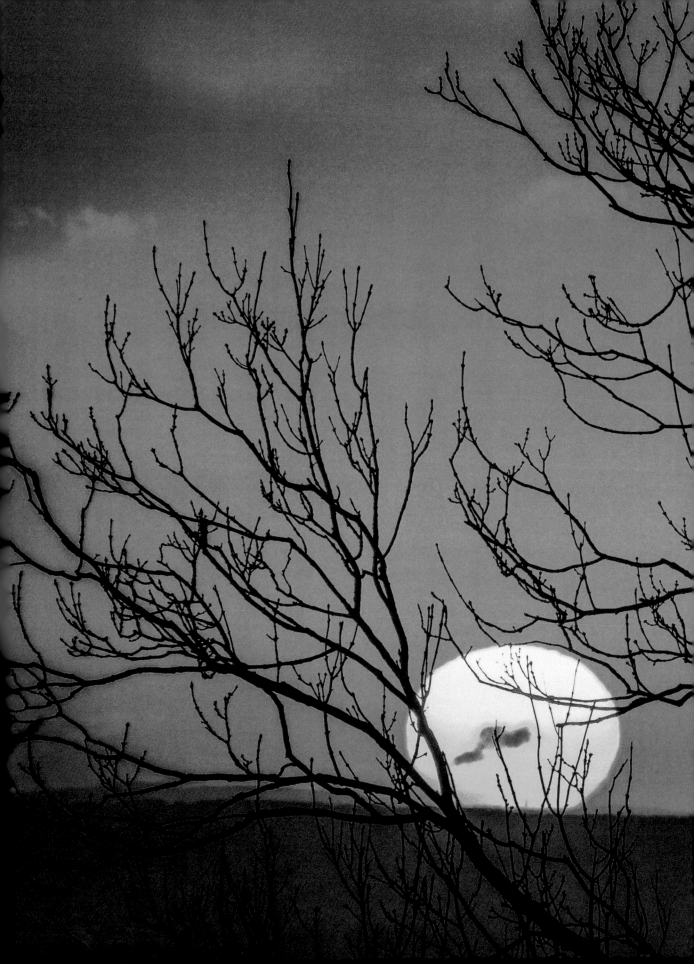

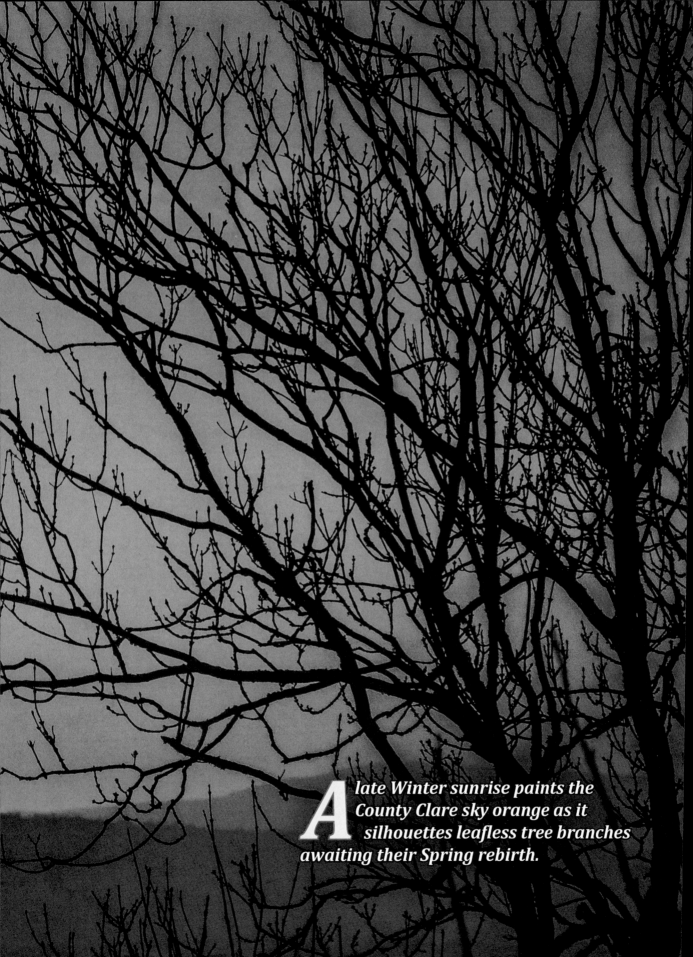

A late Winter sunrise paints the County Clare sky orange as it silhouettes leafless tree branches awaiting their Spring rebirth.

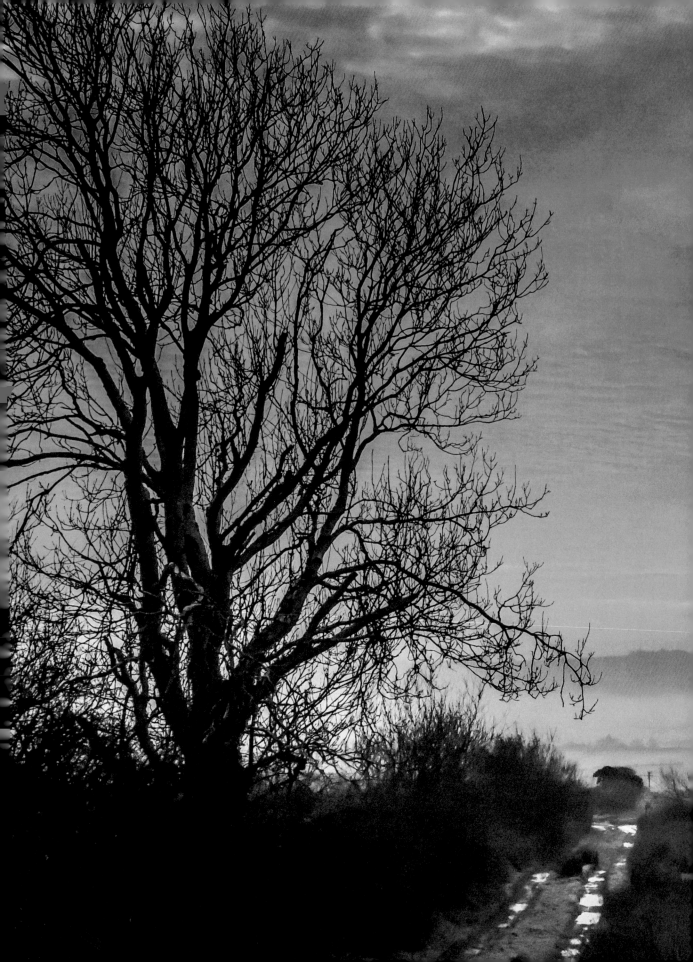

A *farmer's trail leads through a pasture in the hills of Decomade near Lissycasey in County Clare, as a brilliant sunrise announces the new day.*

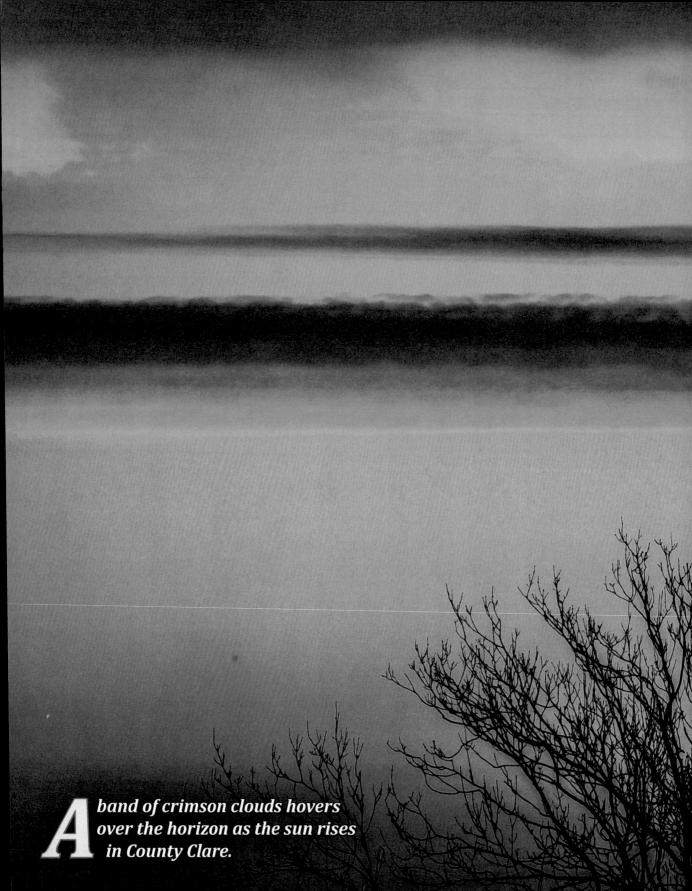

A band of crimson clouds hovers over the horizon as the sun rises in County Clare.

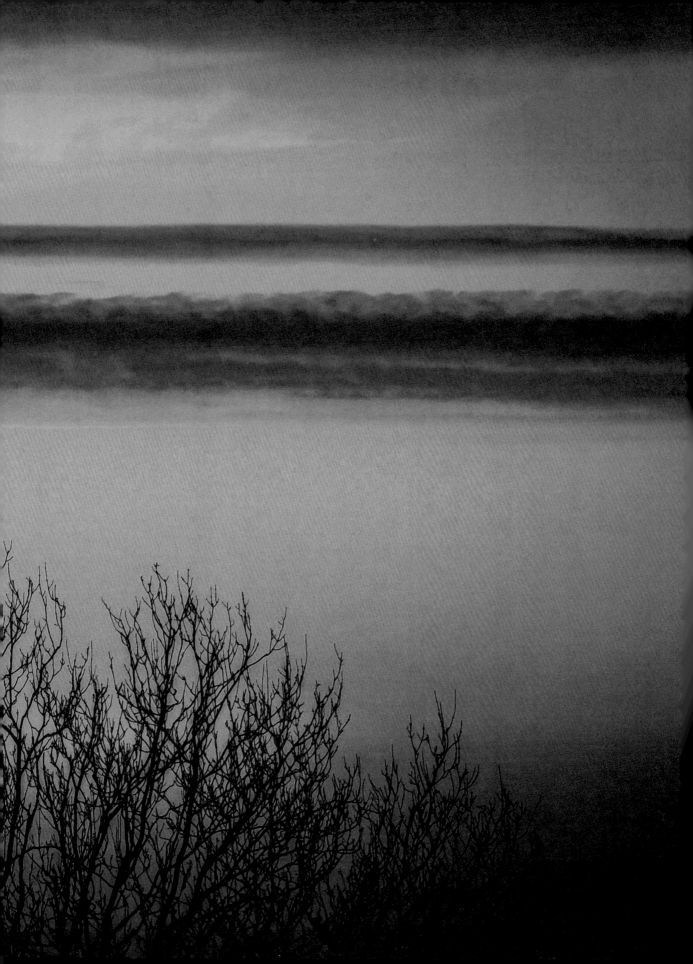

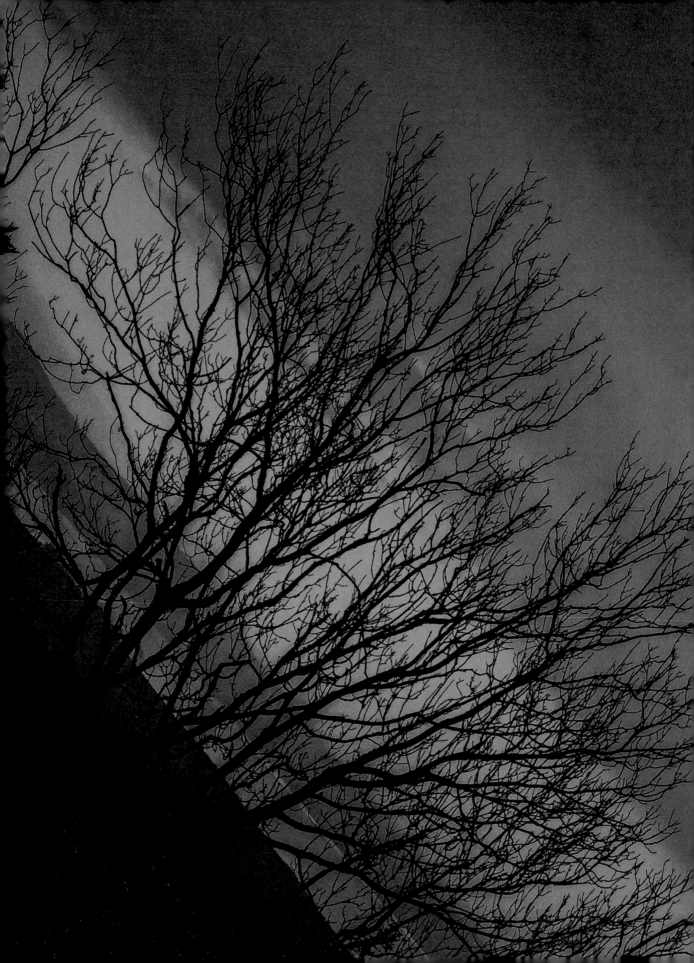

Layers of orange and pink sky precede the rising sun over Ireland's Shannon River Valley.

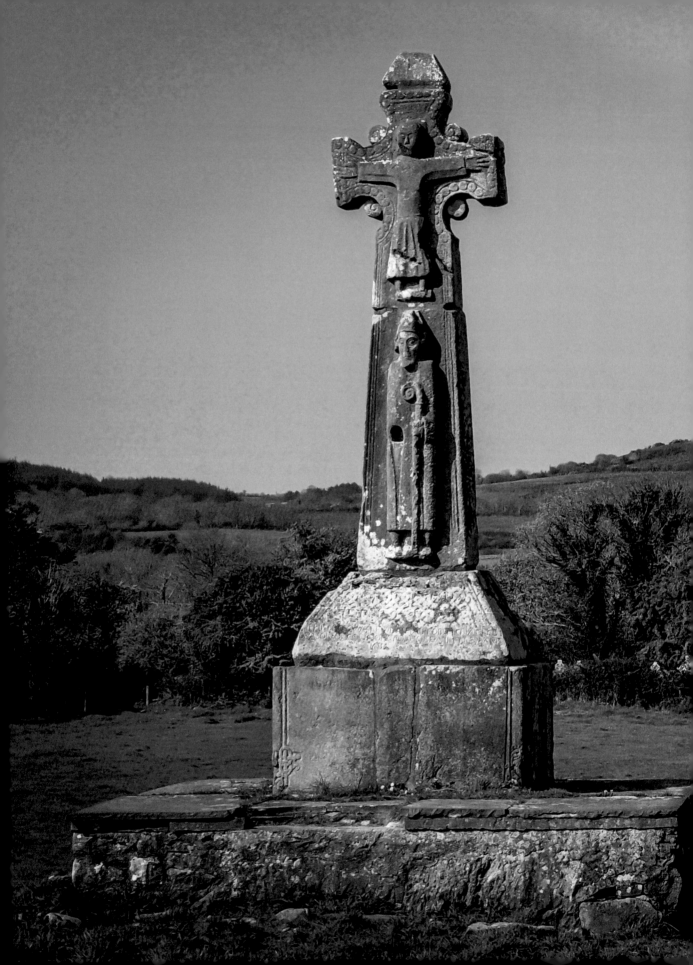

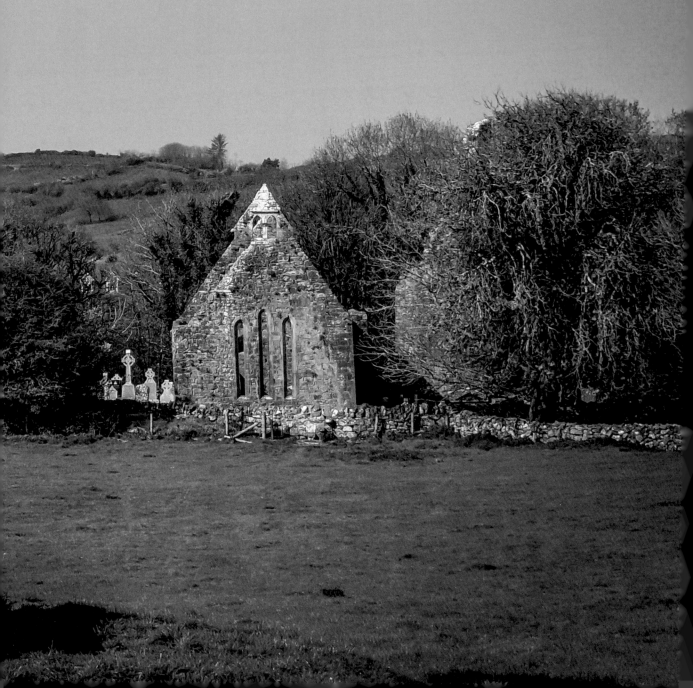

A *12th Century High Cross presides over more than a thousand years of history in the rolling hills and meadows of County Clare near the village of Corofin.*

In the background is the Dysert O'Dea church, built on the site of an early Christian monastery founded by Saint Tola in the 8th Century.

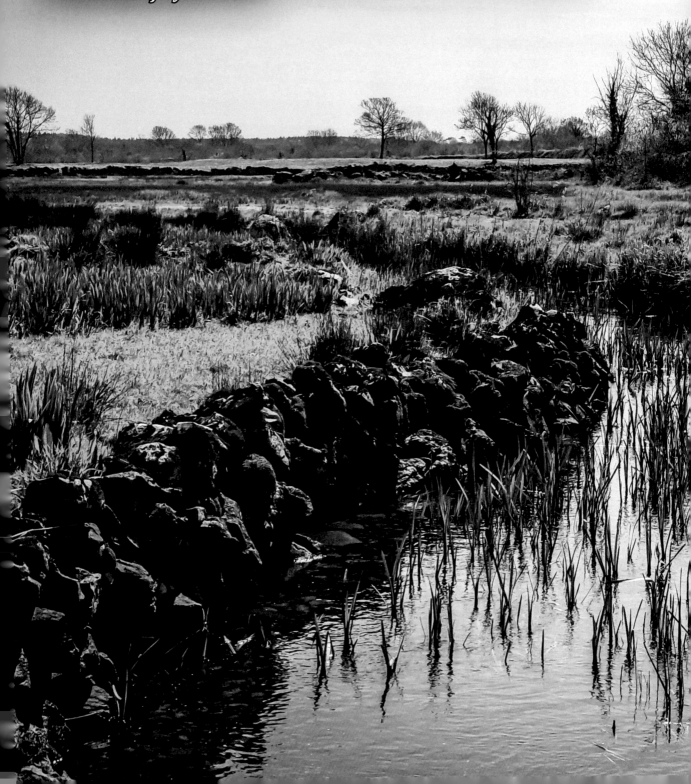

Hundreds of years ago, on May 10, 1318, this gentle stream in the County Clare countryside may have been flowing red with the blood of soldiers of the Gaelic Irish chieftain Connor O'Dea and the Anglo-Norman Richard de Clare, a descendant of Strongbow, in the Battle of Dysert O'Dea.

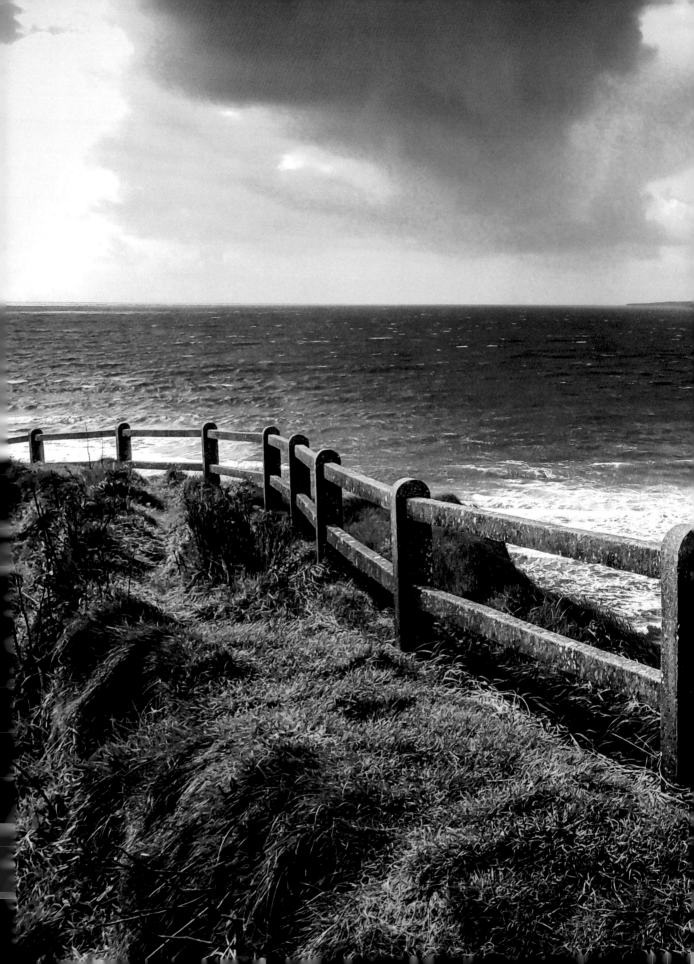

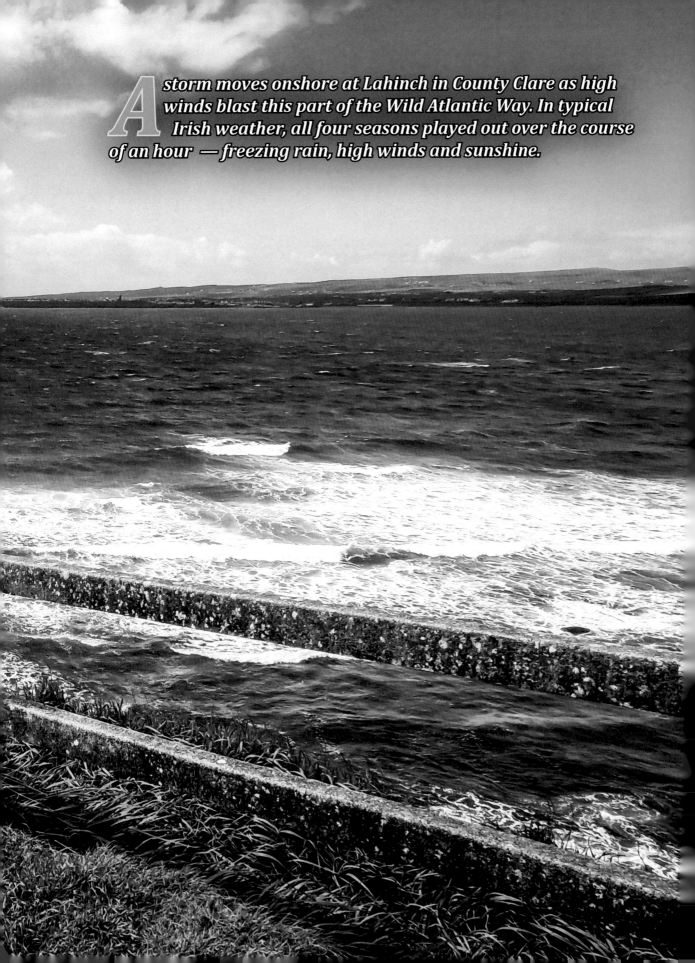

A storm moves onshore at Lahinch in County Clare as high winds blast this part of the Wild Atlantic Way. In typical Irish weather, all four seasons played out over the course of an hour — freezing rain, high winds and sunshine.

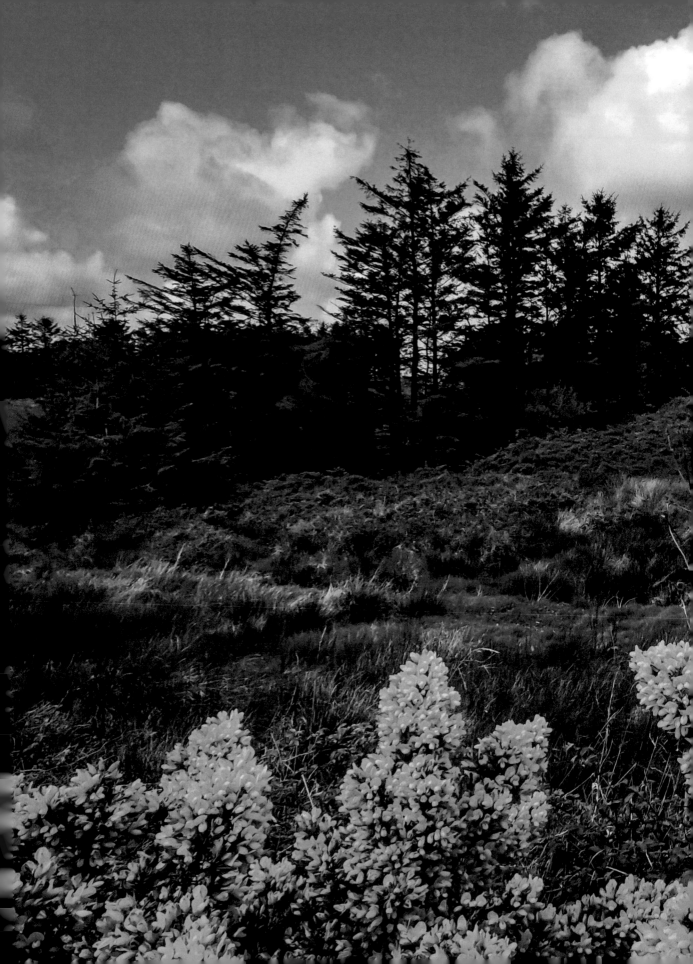

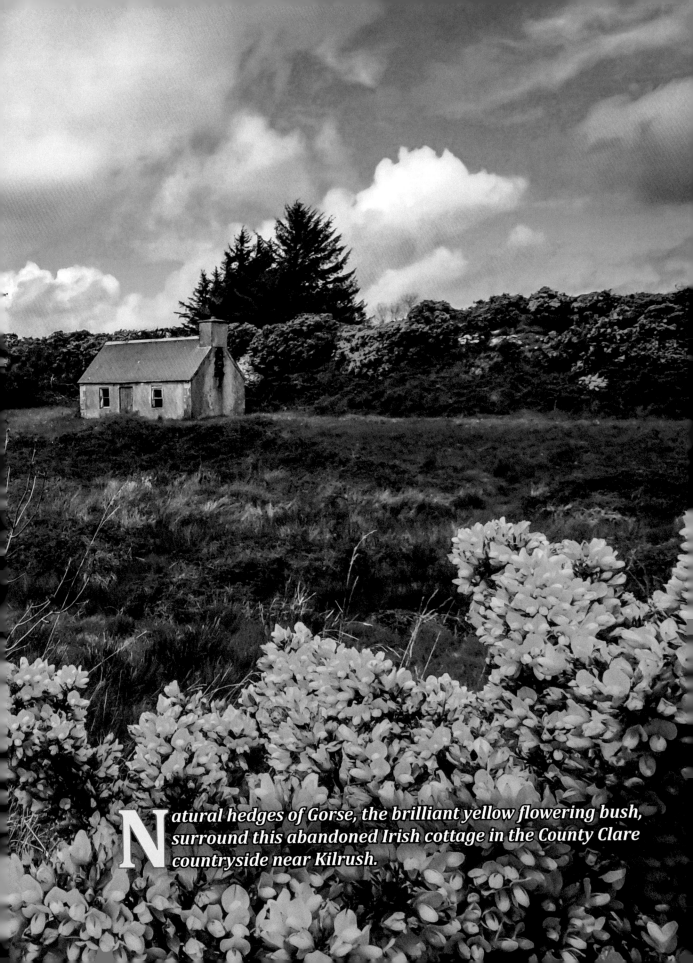

Natural hedges of Gorse, the brilliant yellow flowering bush, surround this abandoned Irish cottage in the County Clare countryside near Kilrush.

Doonagore Castle is one of the most photographed castles in Ireland, more for its romantic Medieval appearance than its inhospitable and possibly gruesome role in events of September 1588 along the County Clare coast near Doolin.

This 16th Century round tower house, now a private holiday home, was the seat of the High Sheriff of Clare, Boetius Clancy, when one of the ships of the Spanish Armada hit the rocks and sank nearby.

Luck was only temporary for the 170 survivors — they were captured by the High Sheriff and hanged as enemies of the British Crown.

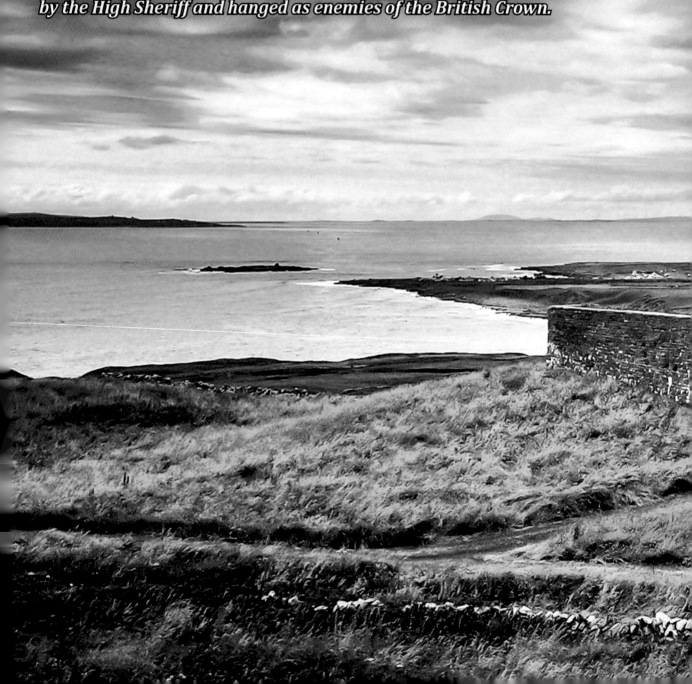

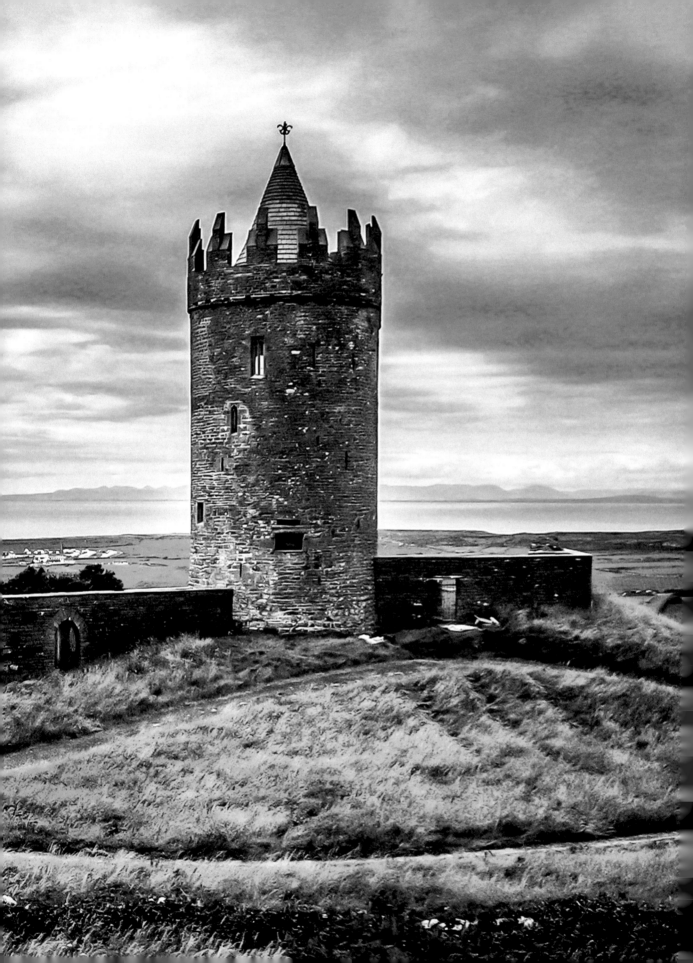

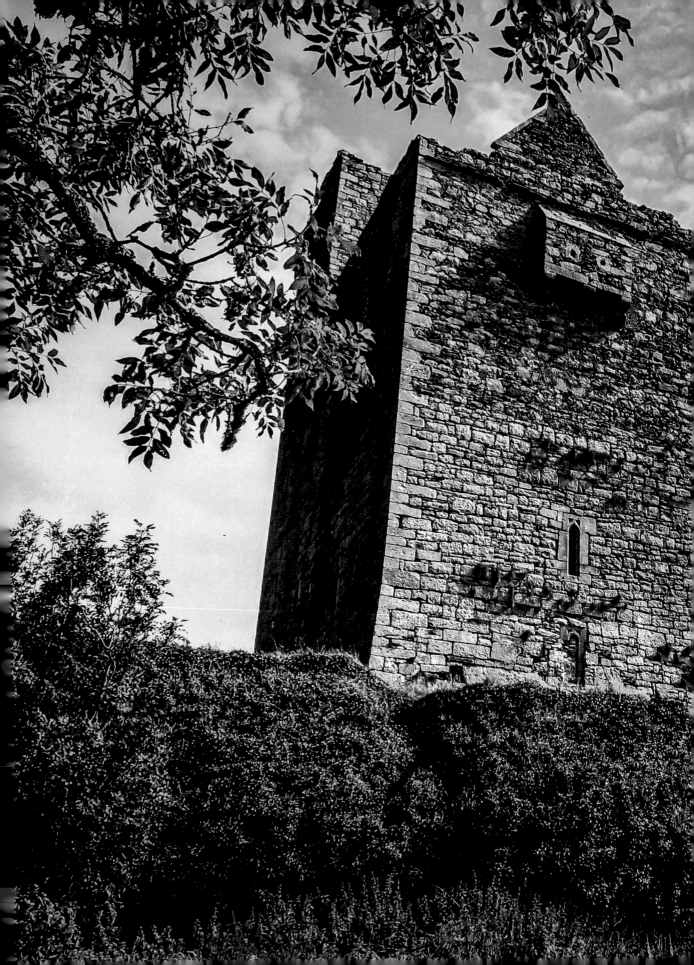

Ballinalacken Castle has commanding vistas of the West Clare countryside, with views out to the Aran Islands and Galway Bay from its perch between Doolin and Lisdoonvarna.

The builders clearly had defense in mind — the fortress is mounted on a rocky limestone cliff with a very sharp drop.

Some records indicate the castle could date back to the 10th Century as a stronghold of the O'Connor Clan, and subsequently was taken over and rebuilt by the O'Briens in the 14th Century.

Tromra Castle, built in the 1400s, towers over the County Clare coast near Quilty and Seafield, where many Spanish sailors lost their lives n 1588 when stormy weather drove their ship on the rocks.

While the current configuration of the castle was built in the 1400s, records indicate some sort of structure was on this site as early as 1215.

Believed to have been built for the Teige O'Brien Clan, the castle's owners and residents changed multiple times in the face of turf wars and political meanderings.

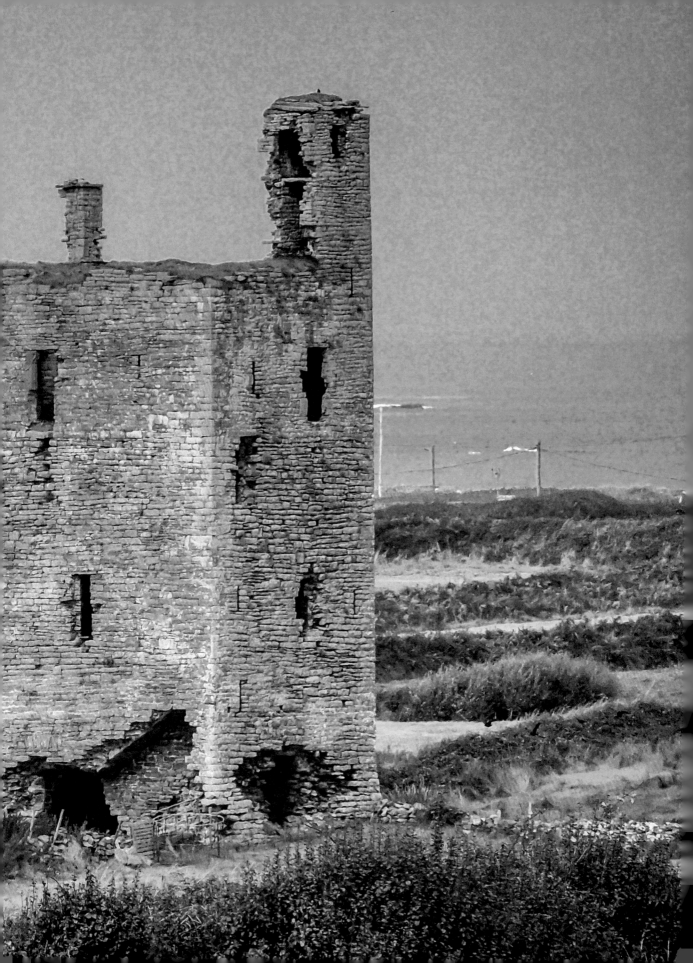

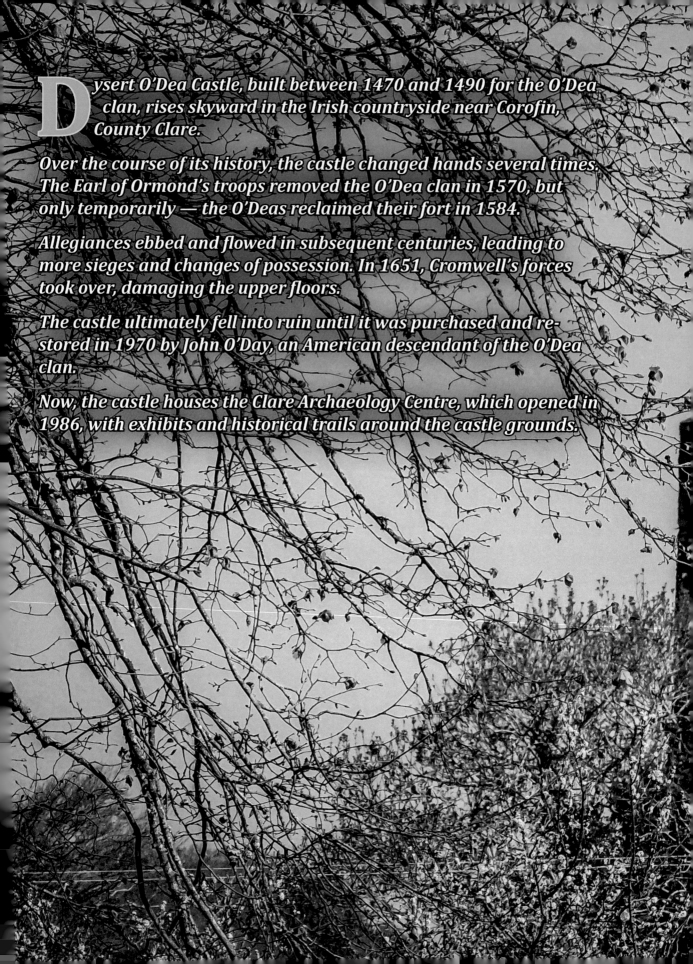

Dysert O'Dea Castle, built between 1470 and 1490 for the O'Dea clan, rises skyward in the Irish countryside near Corofin, County Clare.

Over the course of its history, the castle changed hands several times. The Earl of Ormond's troops removed the O'Dea clan in 1570, but only temporarily — the O'Deas reclaimed their fort in 1584.

Allegiances ebbed and flowed in subsequent centuries, leading to more sieges and changes of possession. In 1651, Cromwell's forces took over, damaging the upper floors.

The castle ultimately fell into ruin until it was purchased and restored in 1970 by John O'Day, an American descendant of the O'Dea clan.

Now, the castle houses the Clare Archaeology Centre, which opened in 1986, with exhibits and historical trails around the castle grounds.

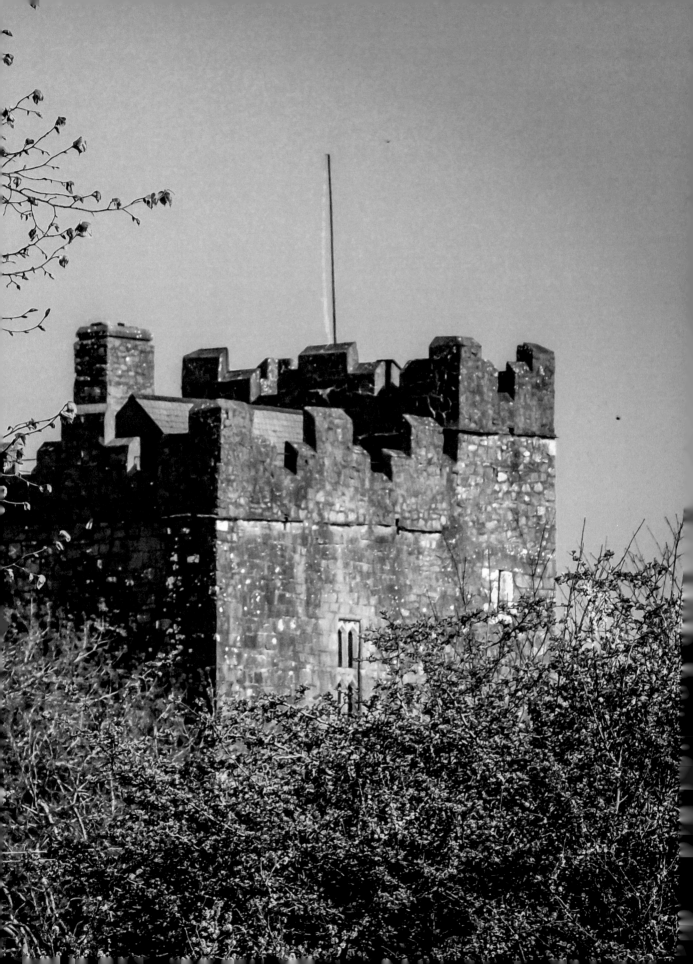

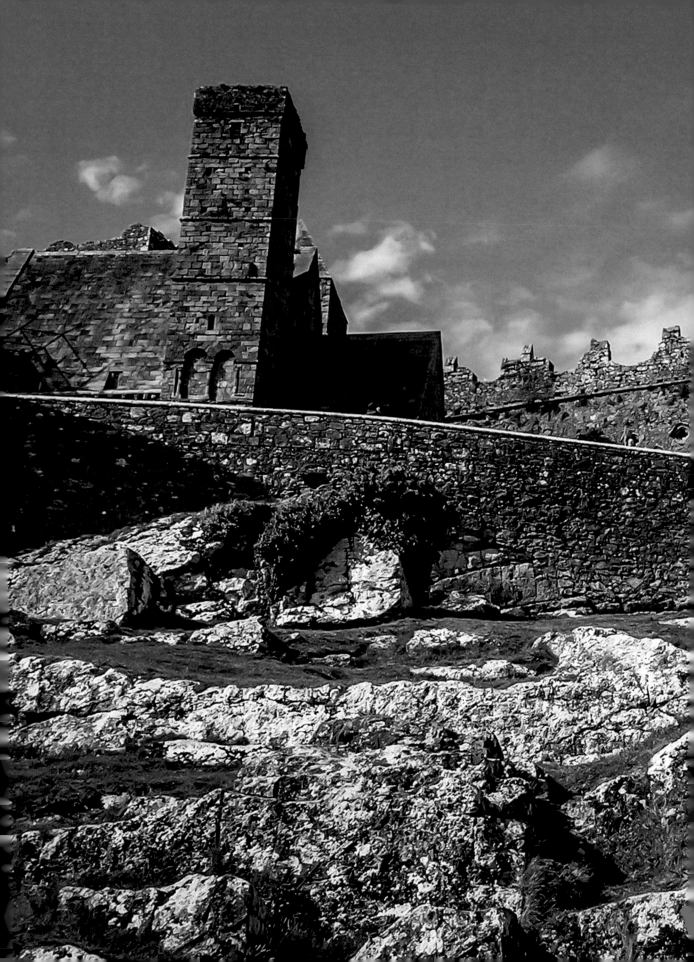

Saint Patrick was believed to have converted the King of Munster to Christianity during the 5th Century at Ireland's iconic Rock of Cashel in County Tipperary.

Also known as "Cashel of the Kings" and "Saint Patrick's Rock," this historic site served as the traditional seat of the Kings of Munster for hundreds of years before the Normans invaded in 1169.

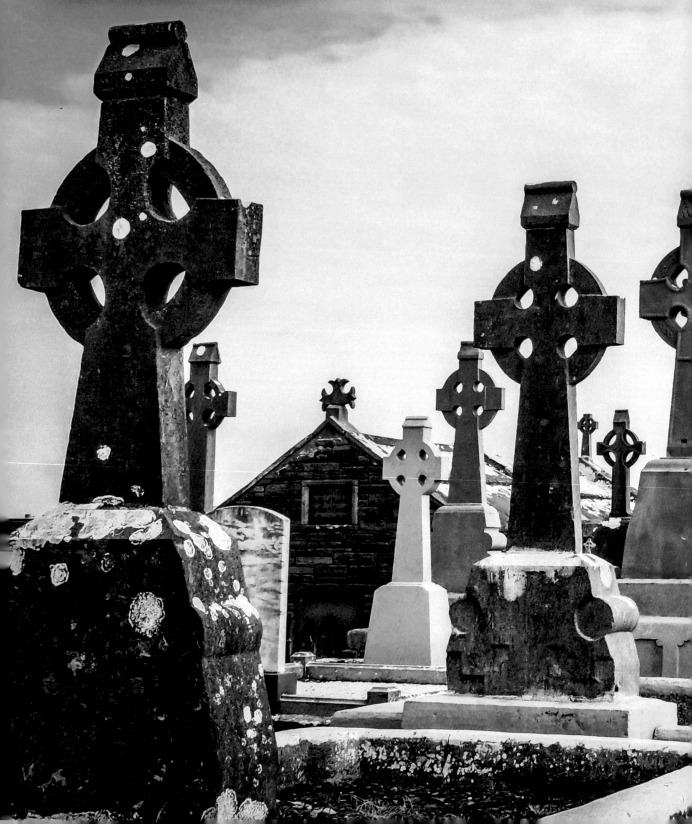

A sea of Celtic crosses watch over graves at the Kilmurry-Ibrickan Graveyard in County Clare. This cemetery has graves dating back to 1777 and remains in use.

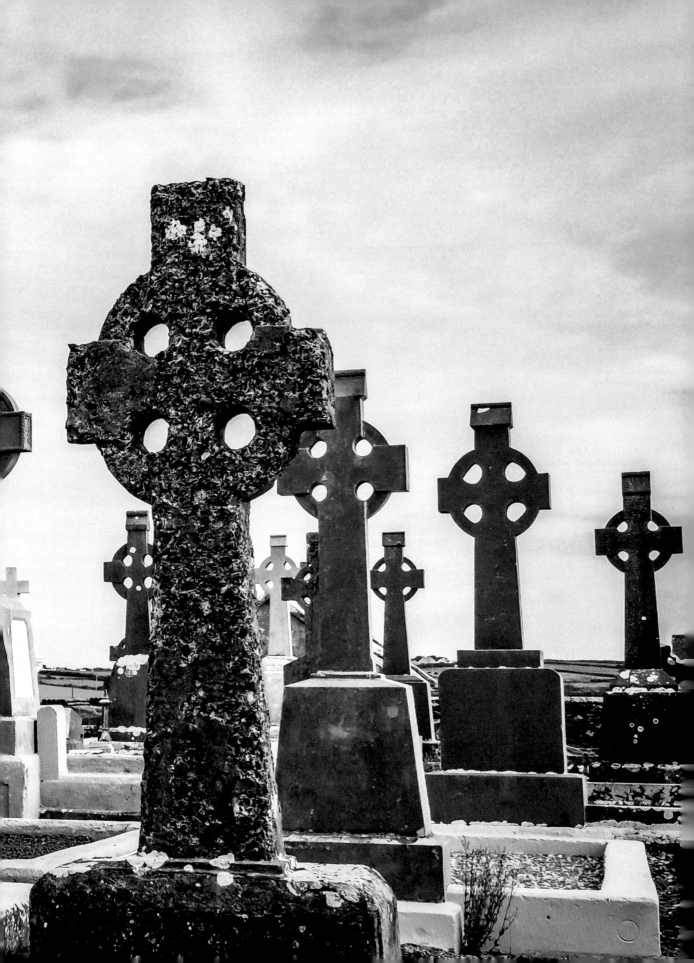

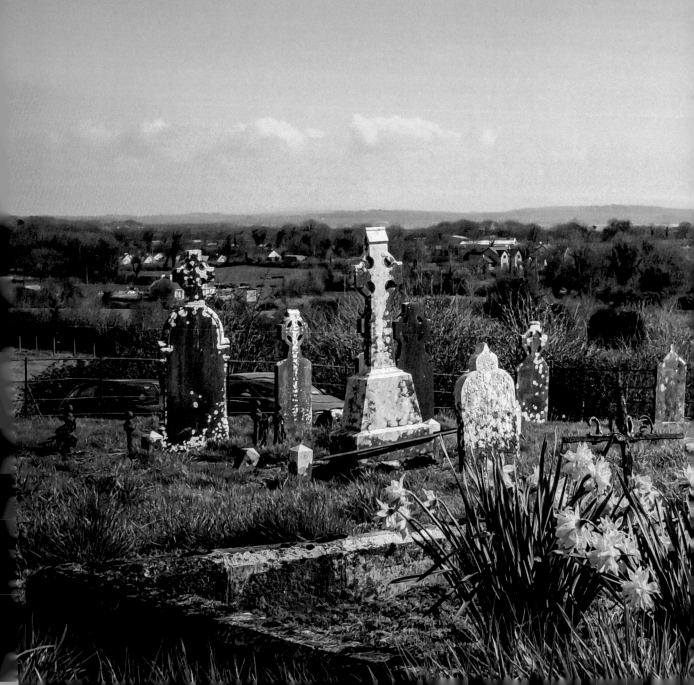

Daffodils brighten a grave under a crisp blue sky in the Killea Cemetery near Ballynacally in County Clare. In the distance is the Shannon Estuary.

This remotely located cemetery originally was a Cillín — a children's burial ground for those not baptized. Eventually, access was improved and it was expanded to allow adult graves.

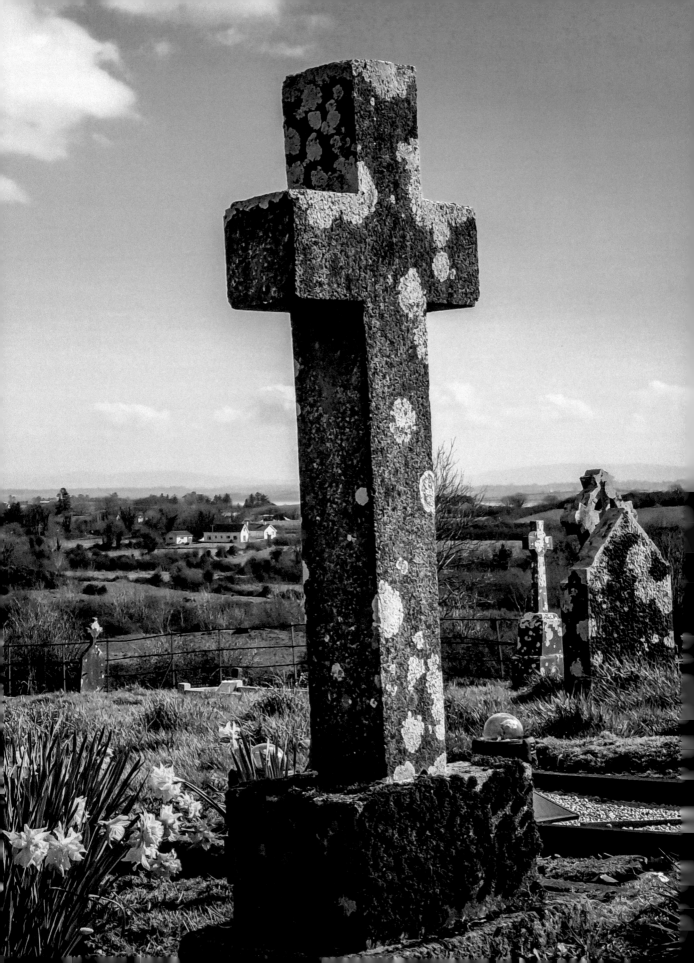

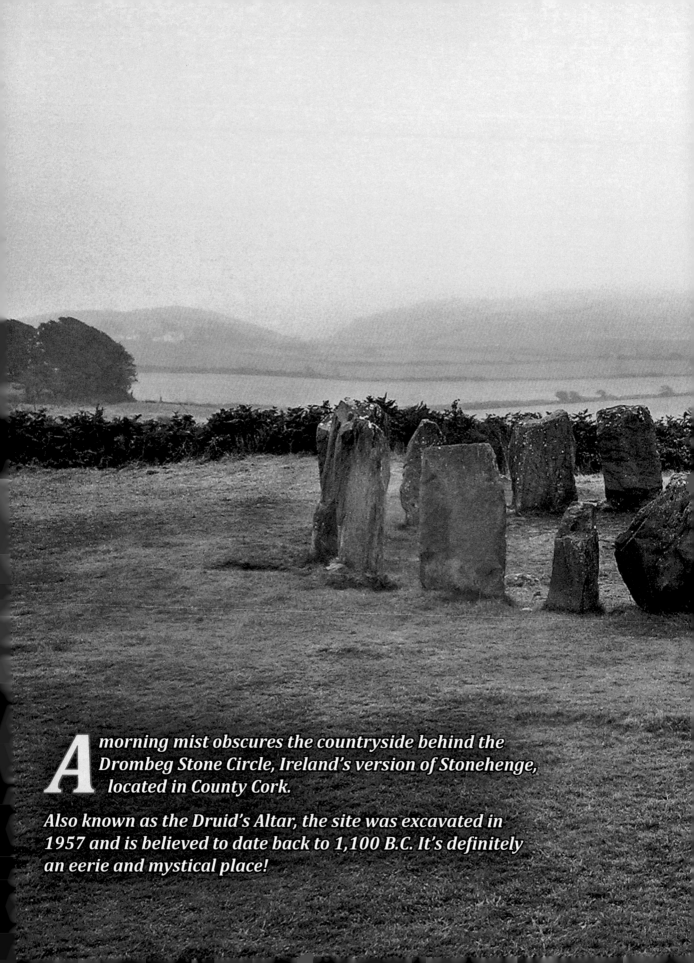

A morning mist obscures the countryside behind the Drombeg Stone Circle, Ireland's version of Stonehenge, located in County Cork.

Also known as the Druid's Altar, the site was excavated in 1957 and is believed to date back to 1,100 B.C. It's definitely an eerie and mystical place!

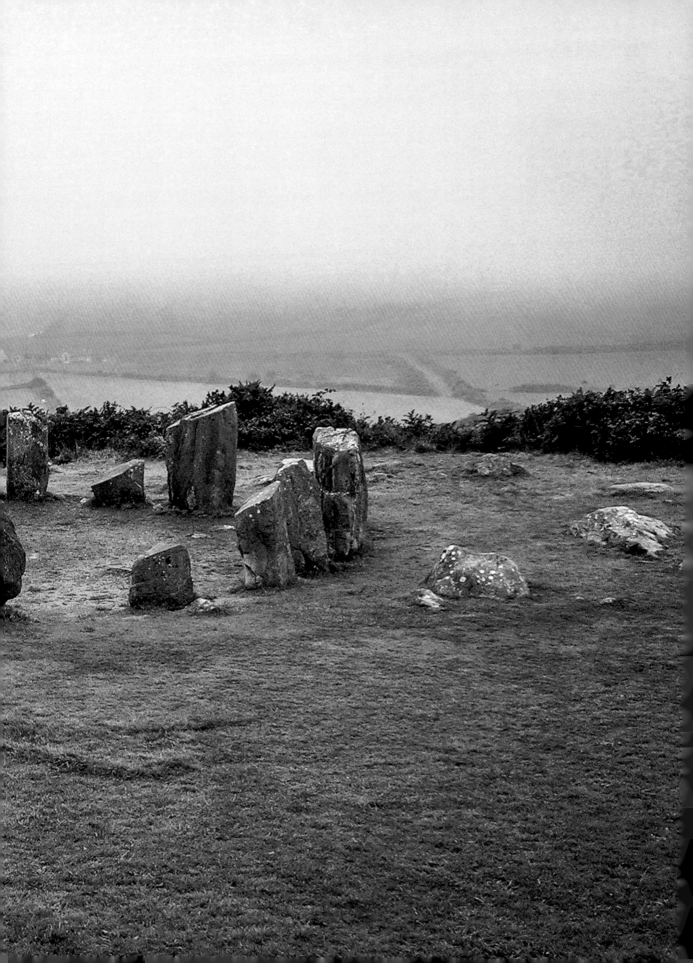

A heavy morning fog creates the illusion of an island in the sky over County Clare.

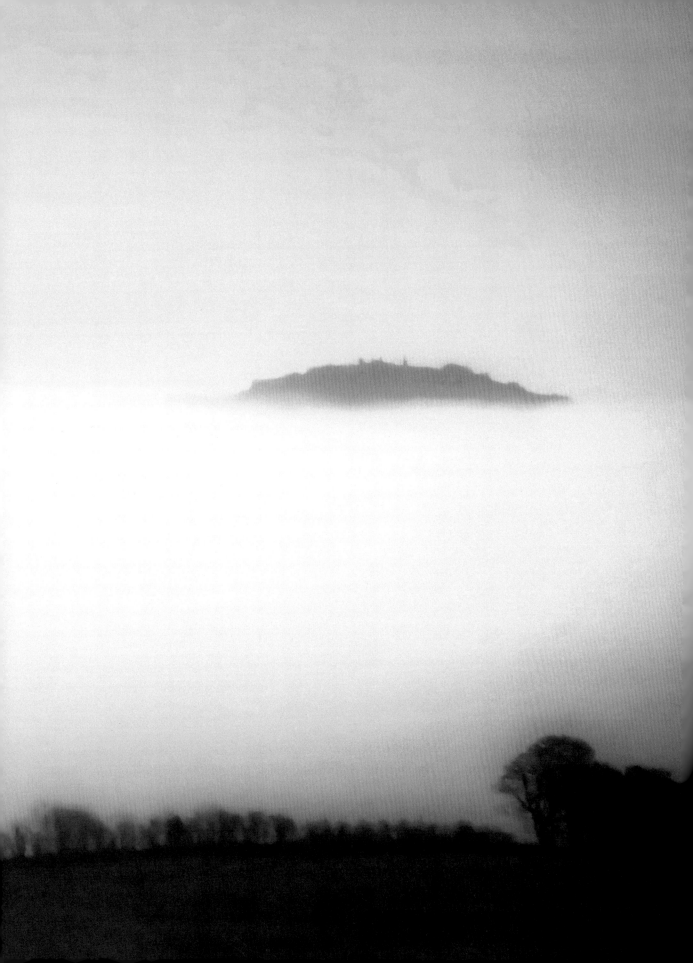

An Irish mist settles in a pasture at Crovraghan near Kildysart in County Clare during this Winter morning.

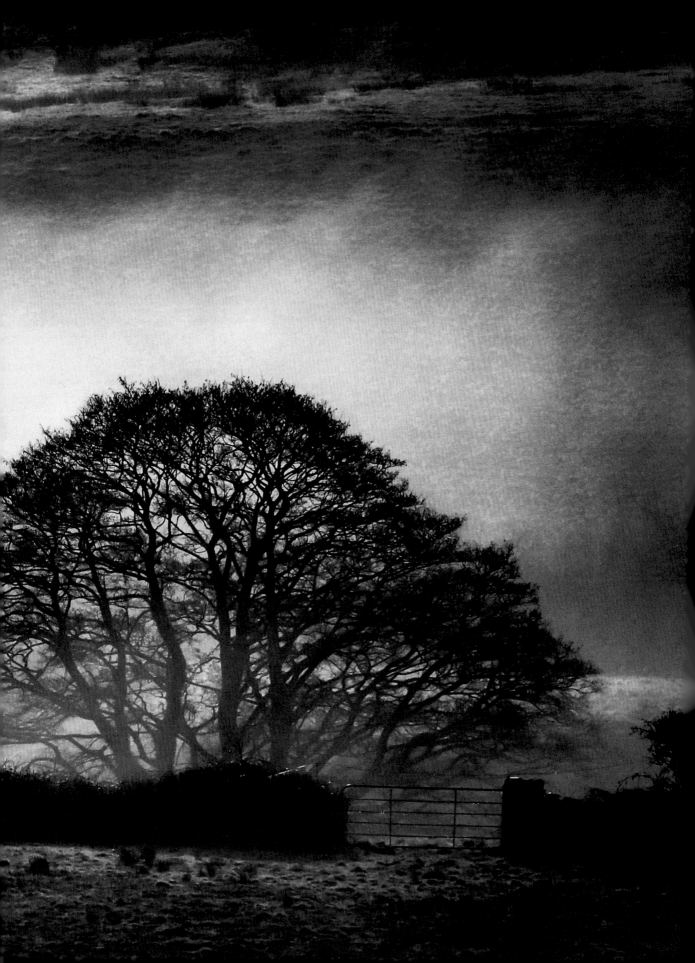

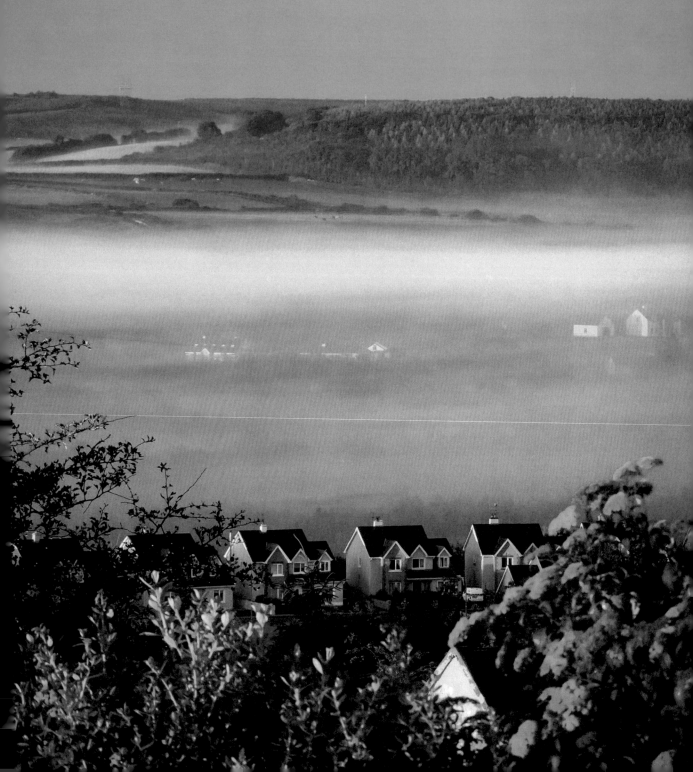

Early morning fog hangs over a housing estate in Lissycasey, County Clare.

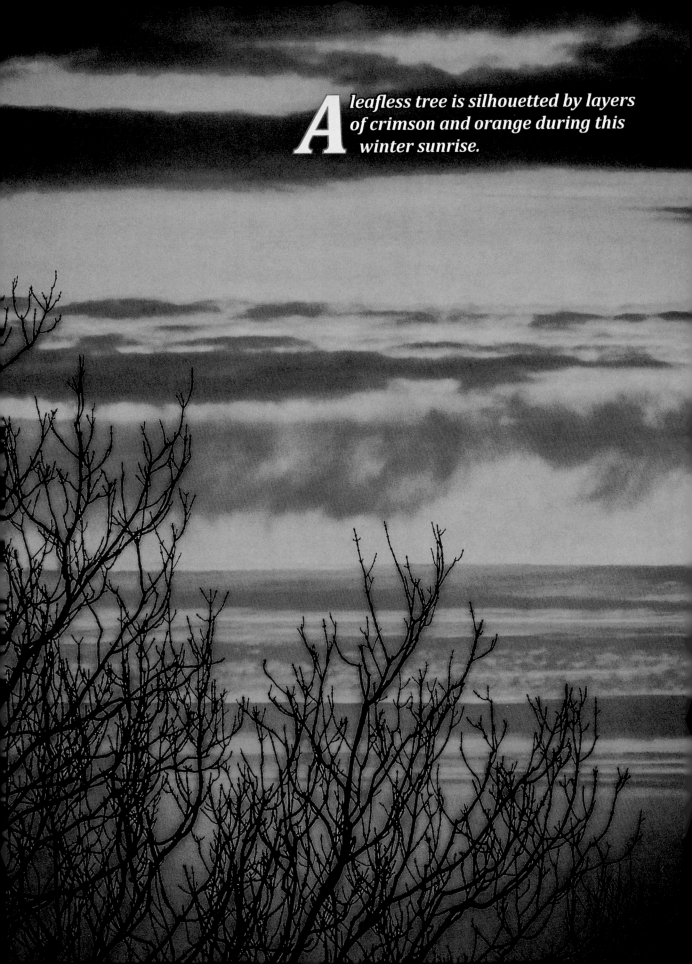

A leafless tree is silhouetted by layers of crimson and orange during this winter sunrise.

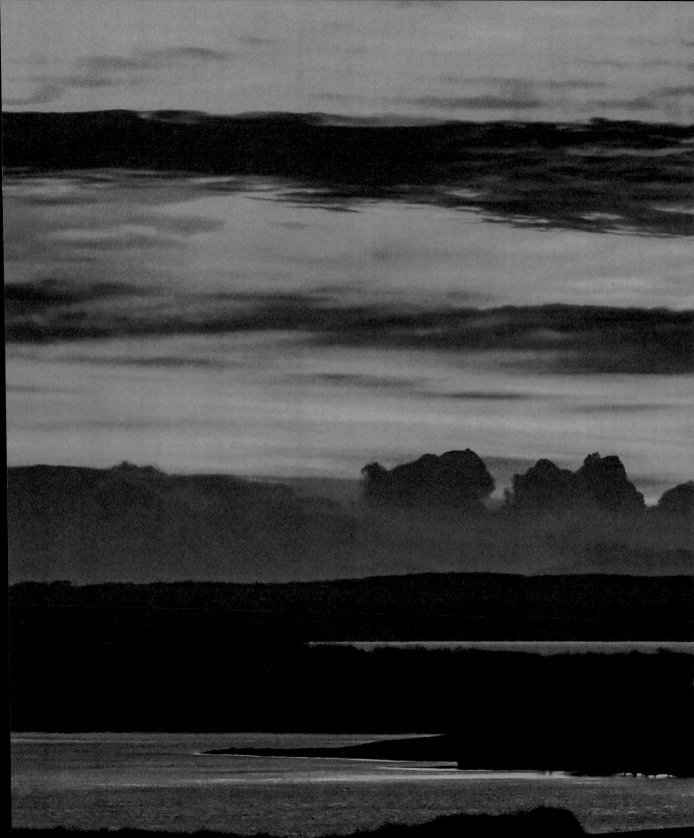

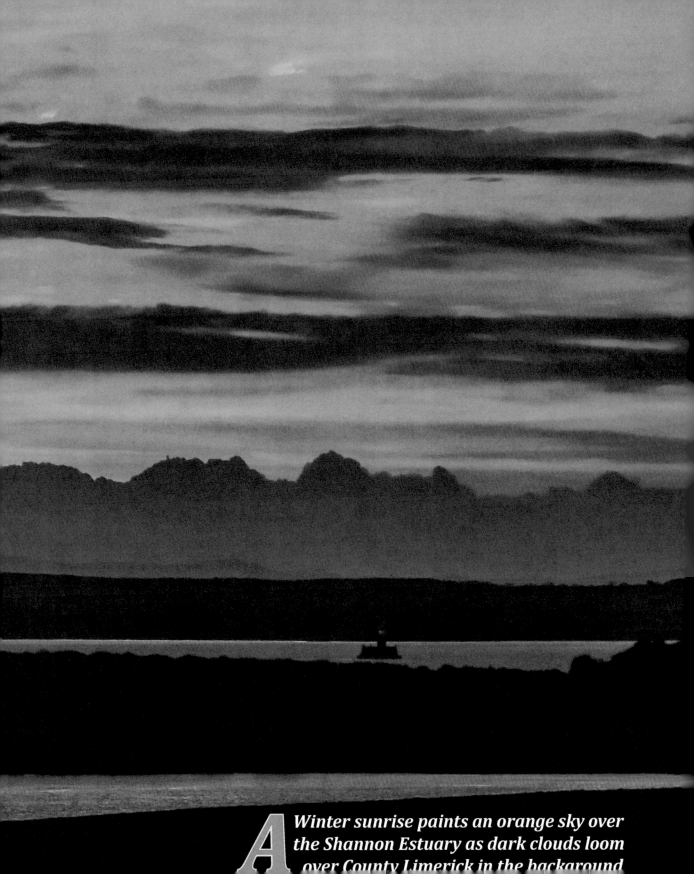

A Winter sunrise paints an orange sky over the Shannon Estuary as dark clouds loom over County Limerick in the background.

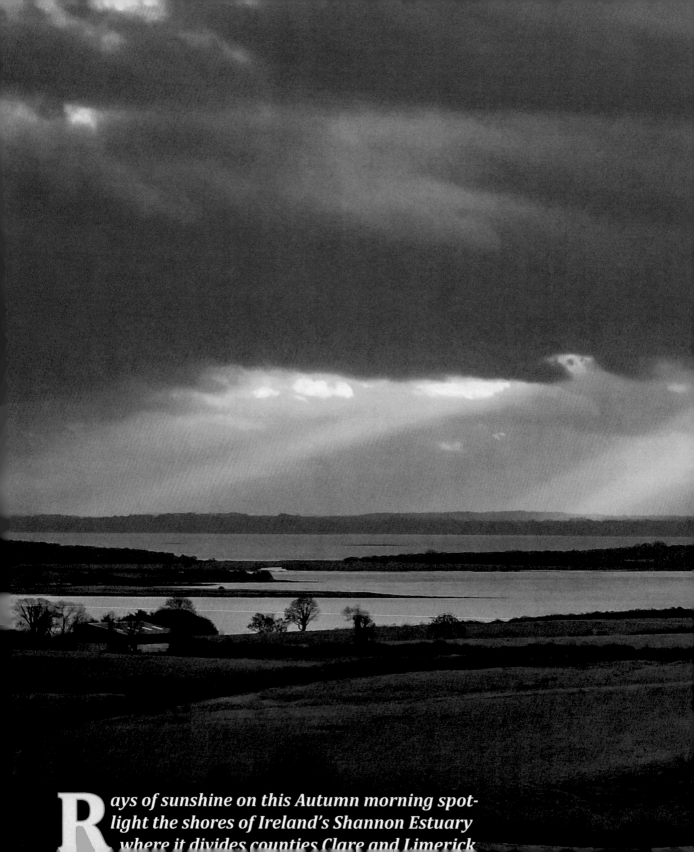

Rays of sunshine on this Autumn morning spot-
light the shores of Ireland's Shannon Estuary
where it divides counties Clare and Limerick

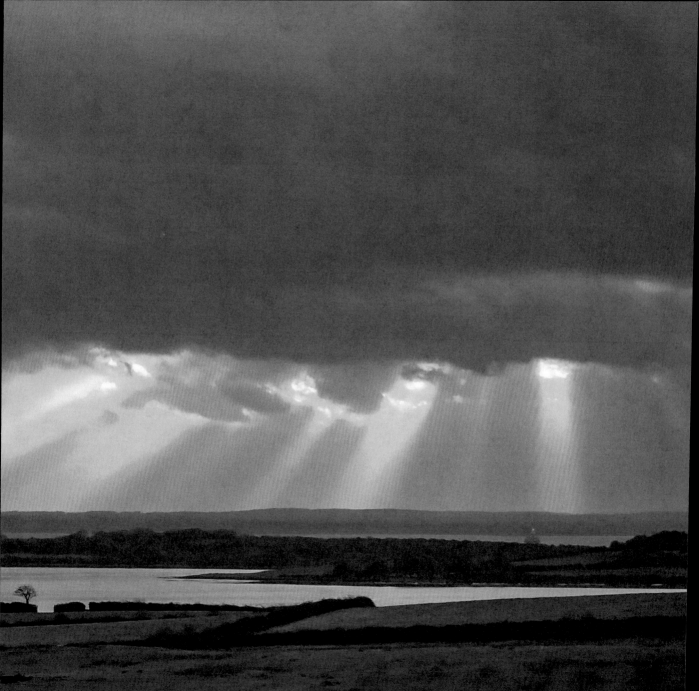

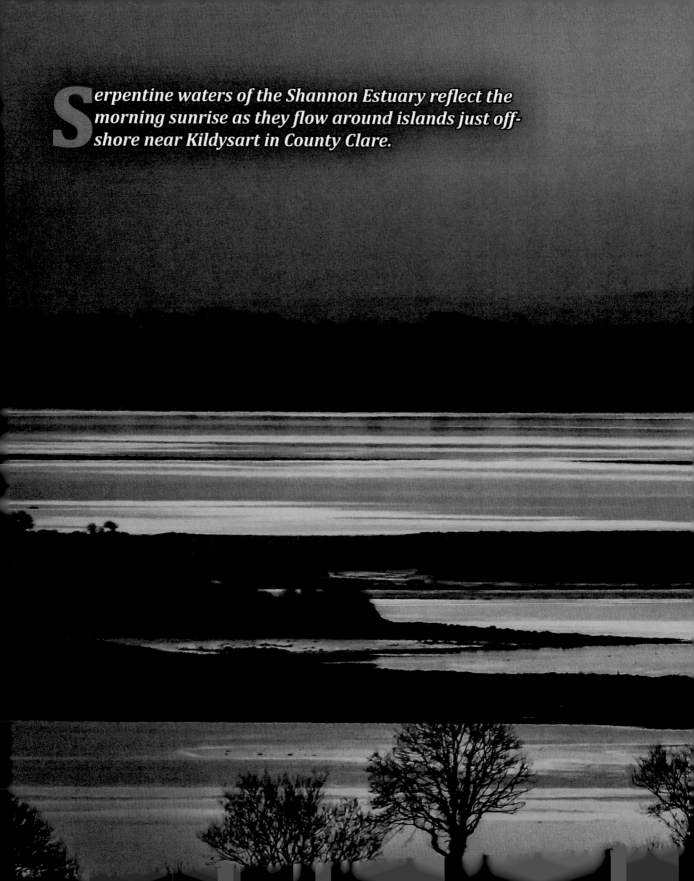

Serpentine waters of the Shannon Estuary reflect the morning sunrise as they flow around islands just off-shore near Kildysart in County Clare.

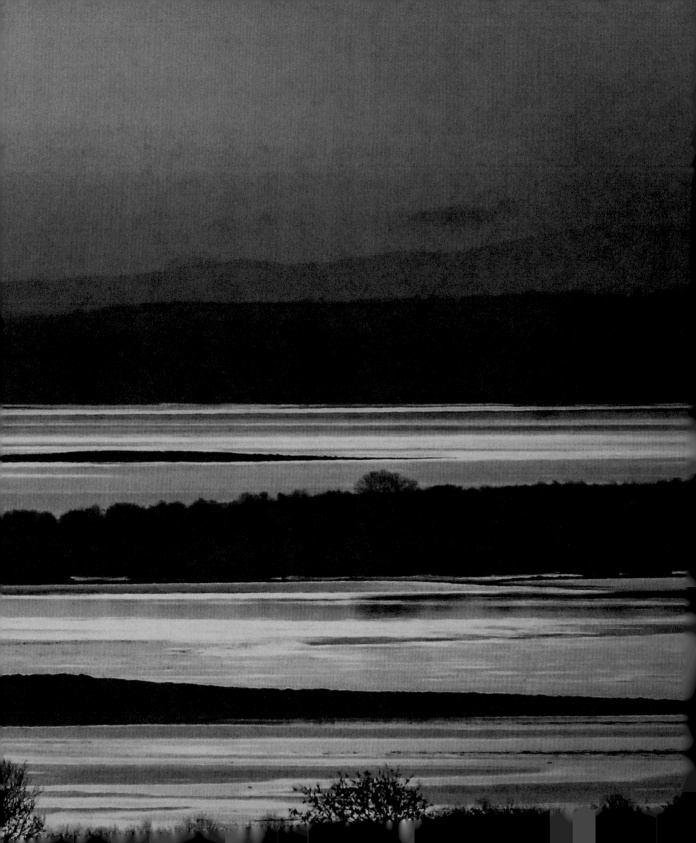

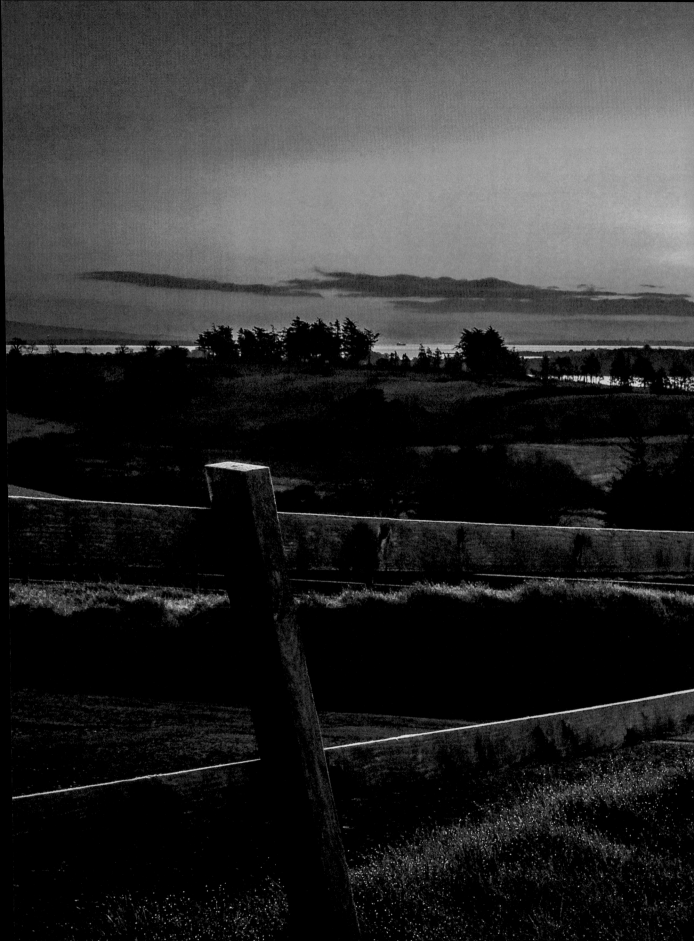

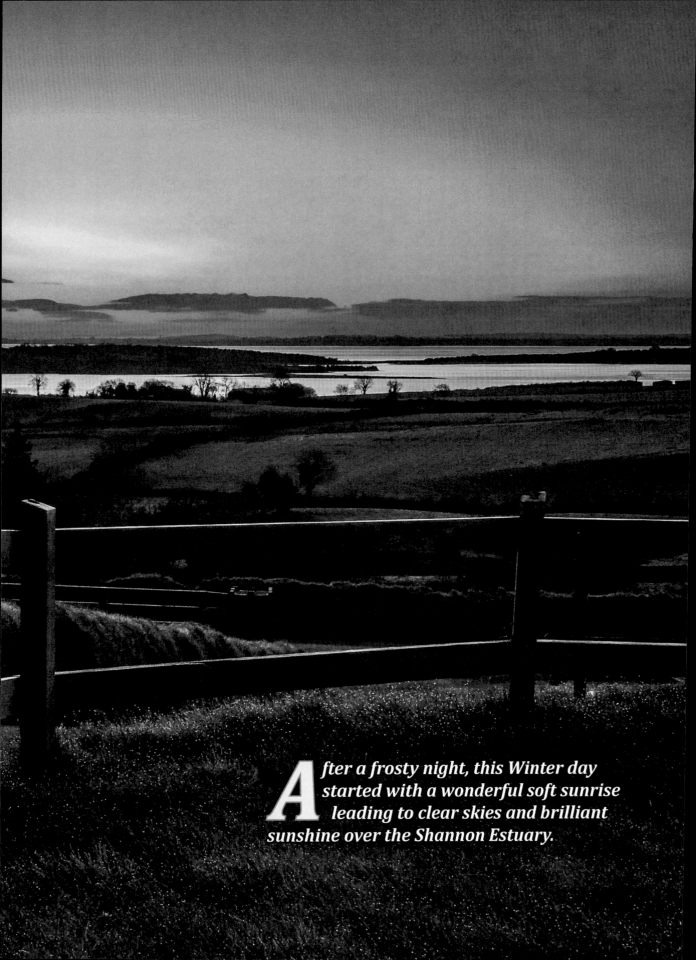

*A*fter a frosty night, this Winter day started with a wonderful soft sunrise leading to clear skies and brilliant sunshine over the Shannon Estuary.

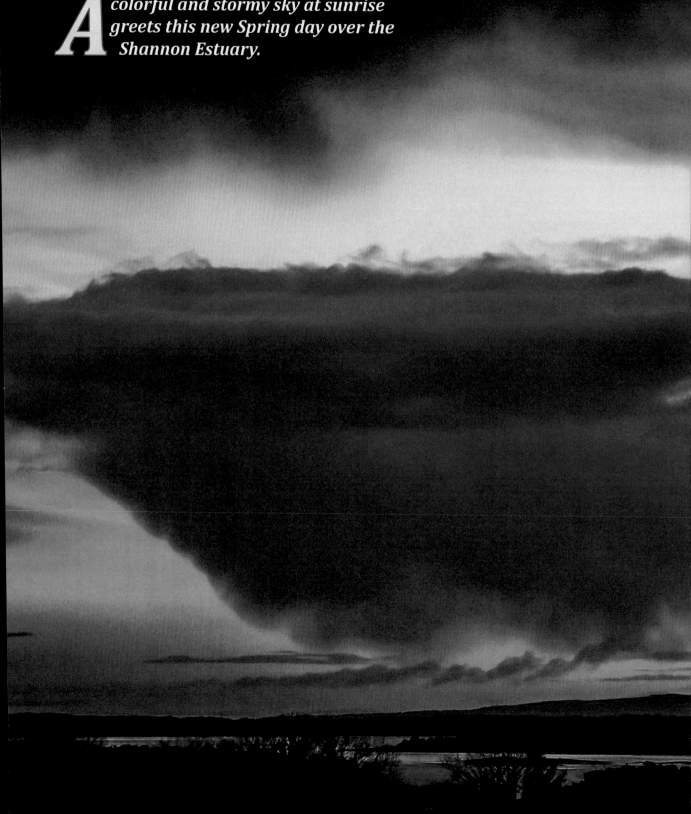

A colorful and stormy sky at sunrise greets this new Spring day over the Shannon Estuary.

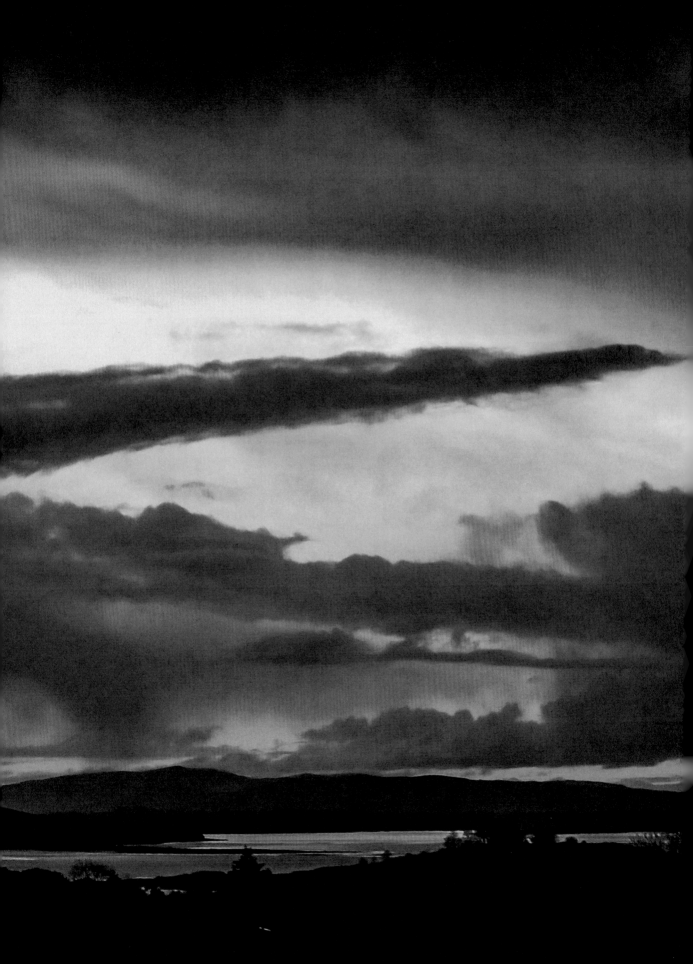

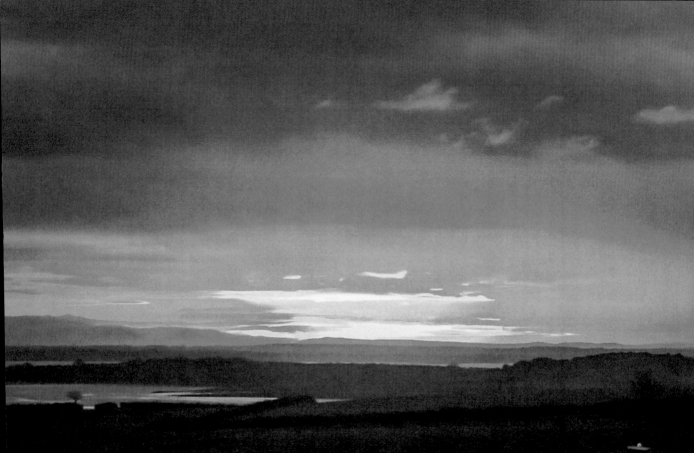

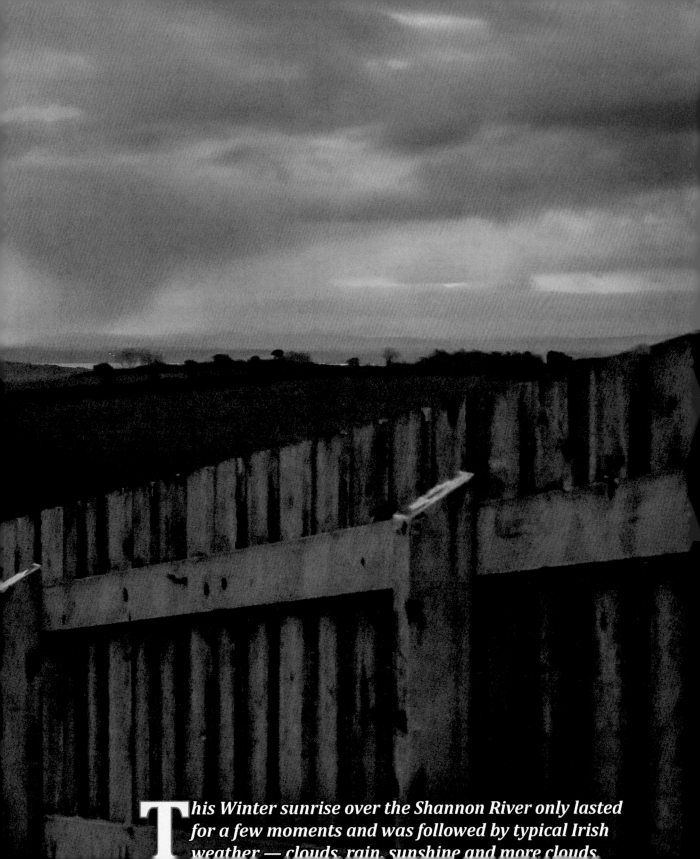

This Winter sunrise over the Shannon River only lasted for a few moments and was followed by typical Irish weather — clouds, rain, sunshine and more clouds.

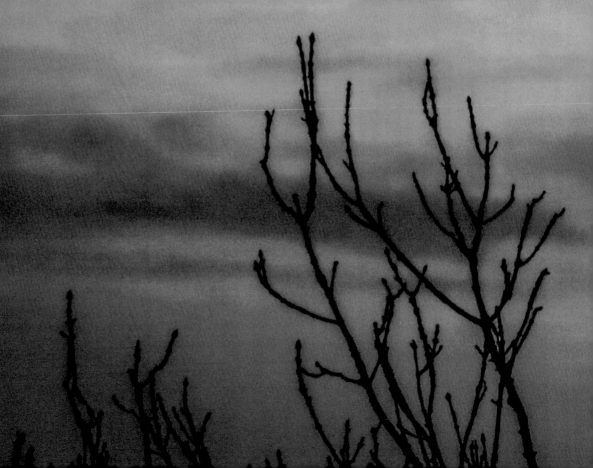

A late Autumn sunrise glazes clouds over County Clare with a frosting of hot pink light.

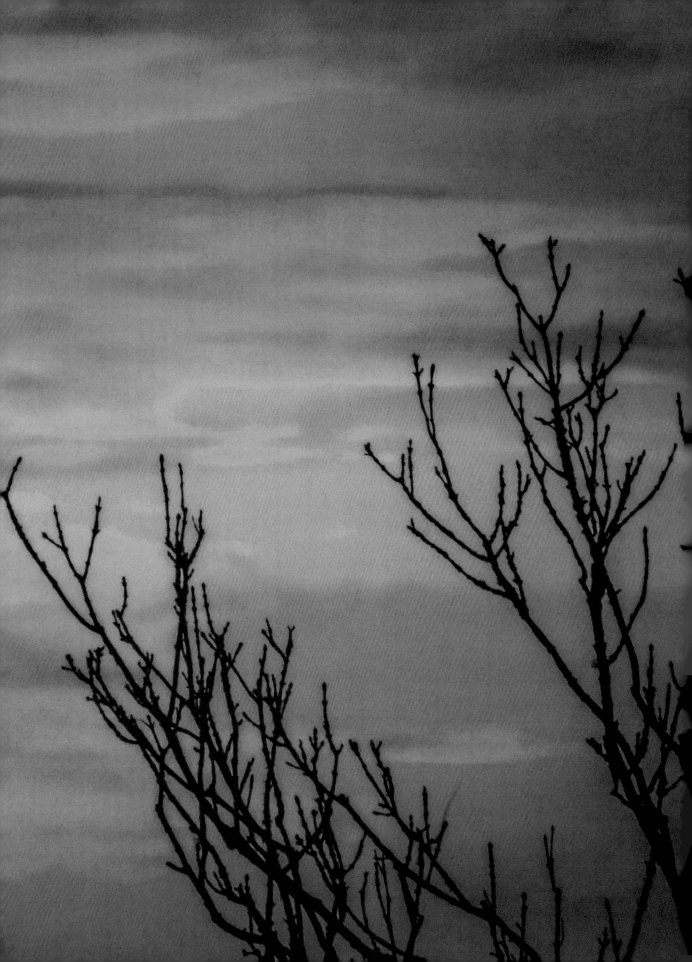

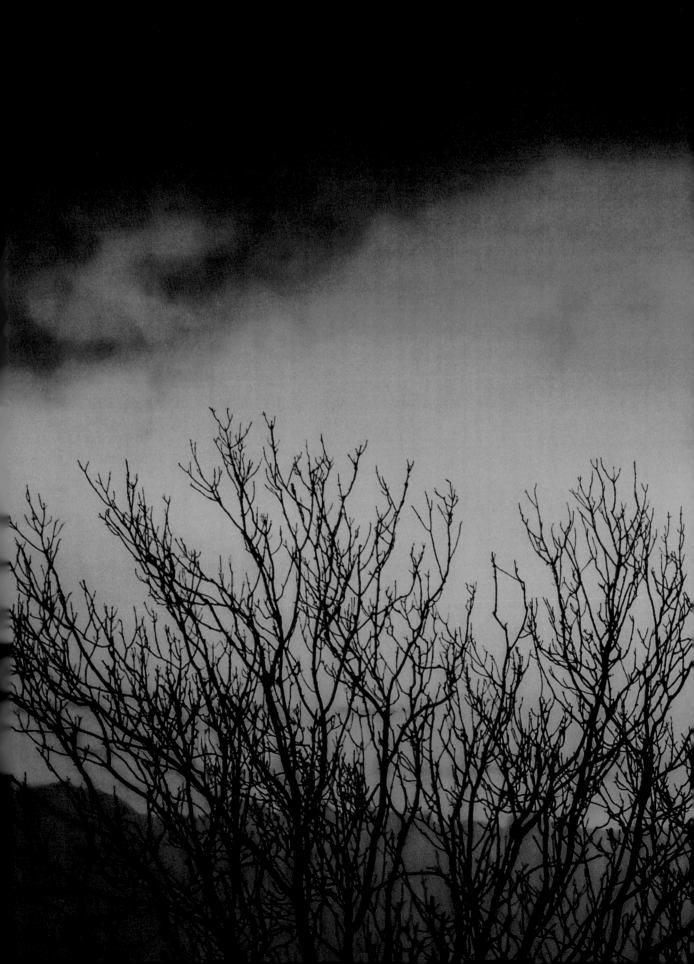

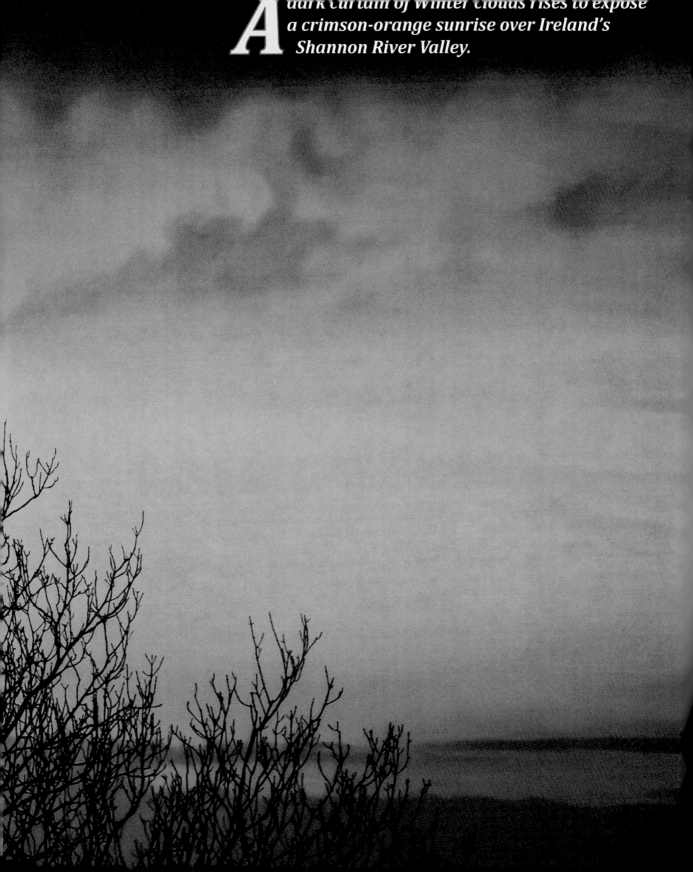

A dark curtain of winter clouds rises to expose a crimson-orange sunrise over Ireland's Shannon River Valley.

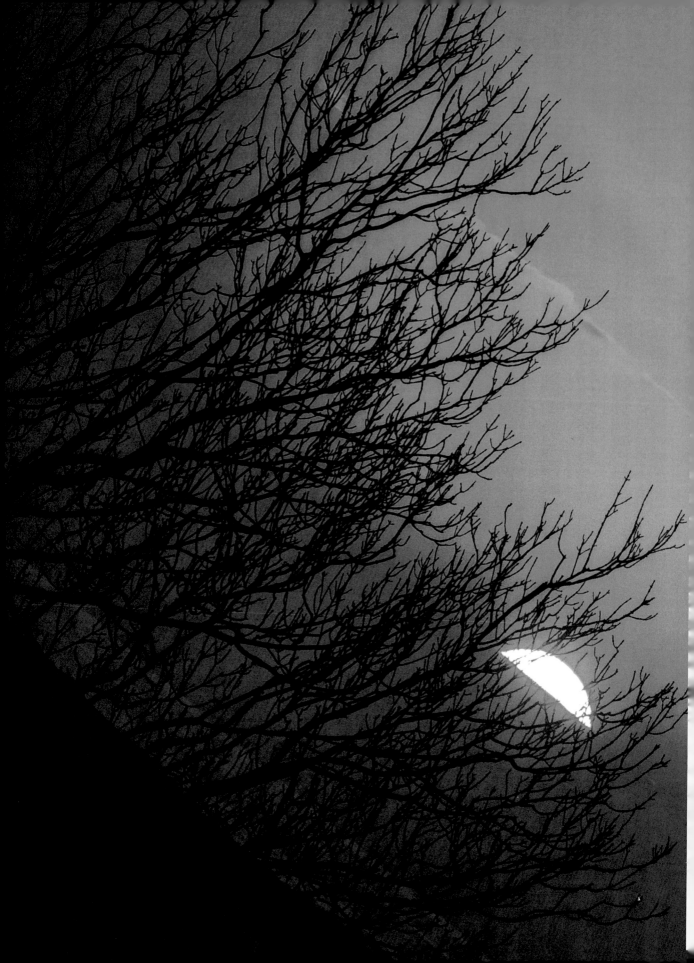

A rising sun peeks out from behind a hibernating tree during Winter in Western Ireland.

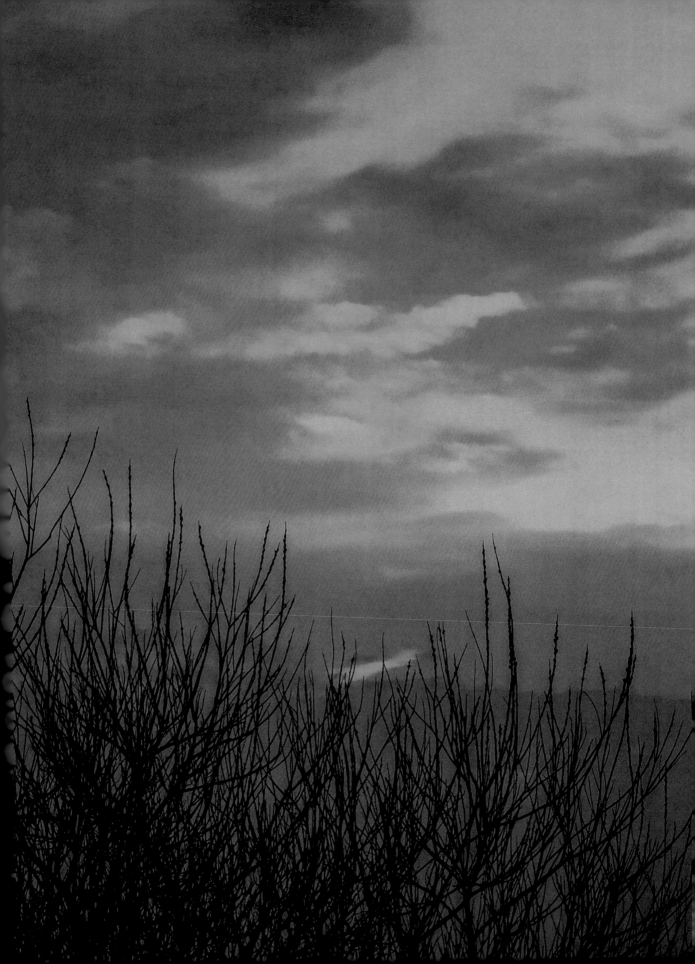

Flaming orange clouds herald the arrival of the Winter morning sun over Western Ireland.

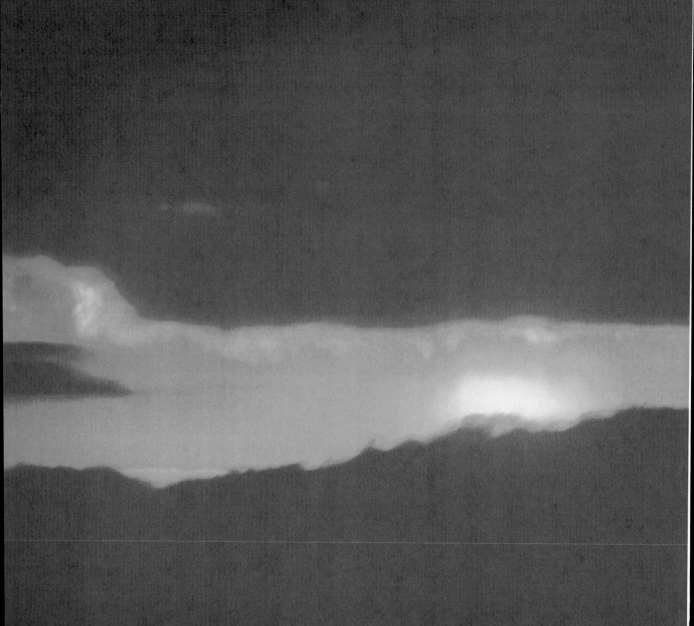

A brilliant rising sun reaches through a crevice in Spring cloud cover in the skies over County Clare.

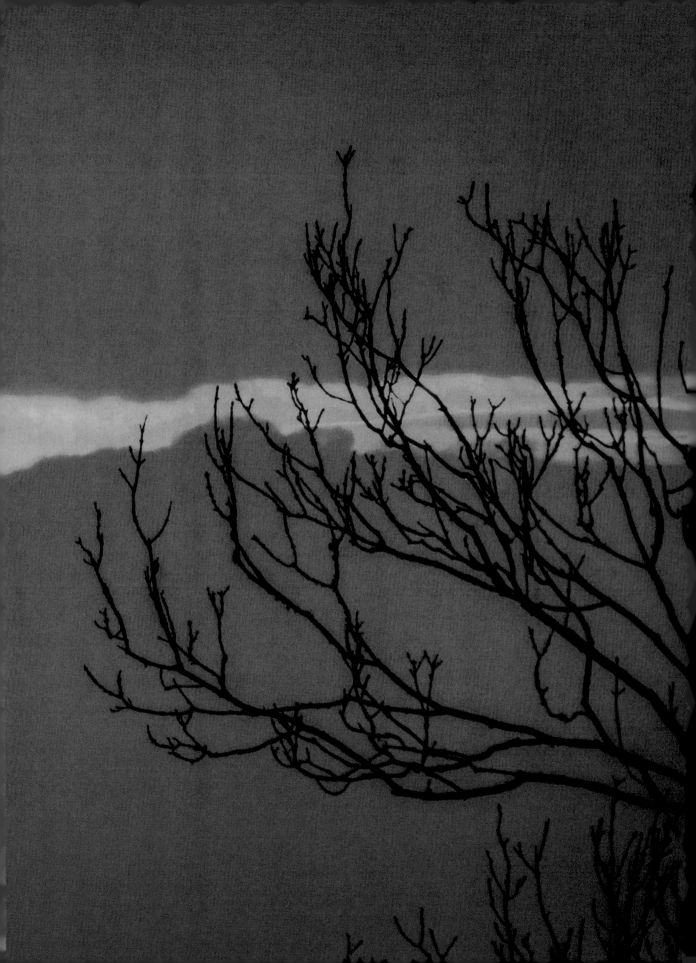

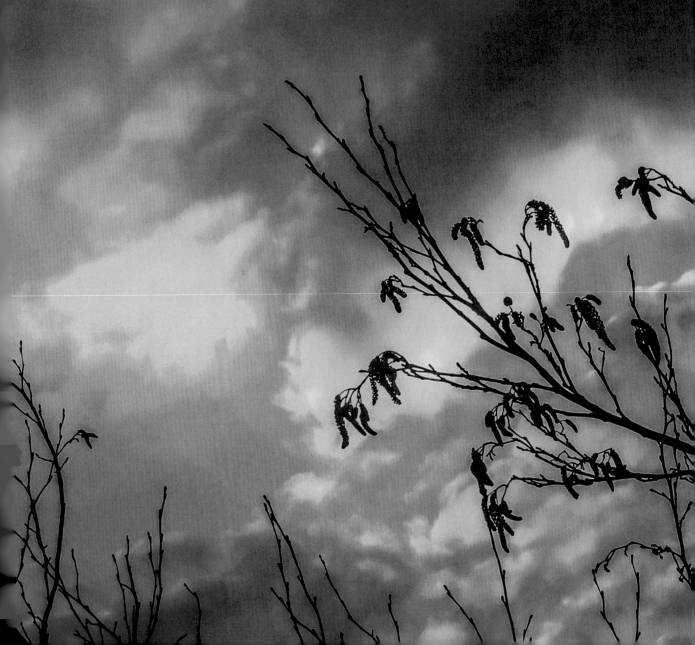

Springtime clouds part to reveal a blue sky at sunrise over the Irish countryside in County Clare.

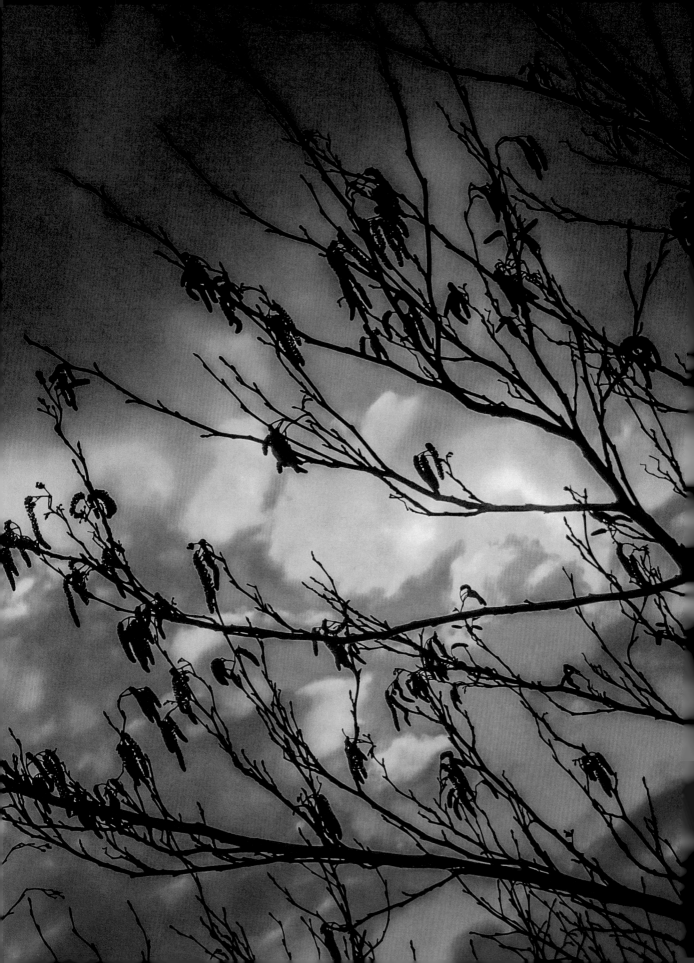

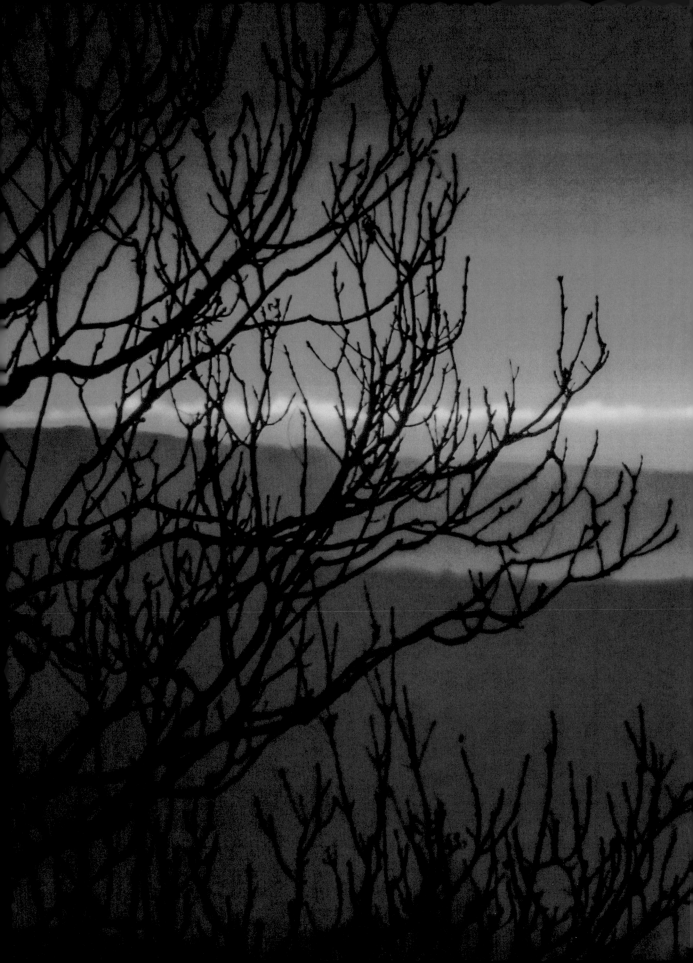

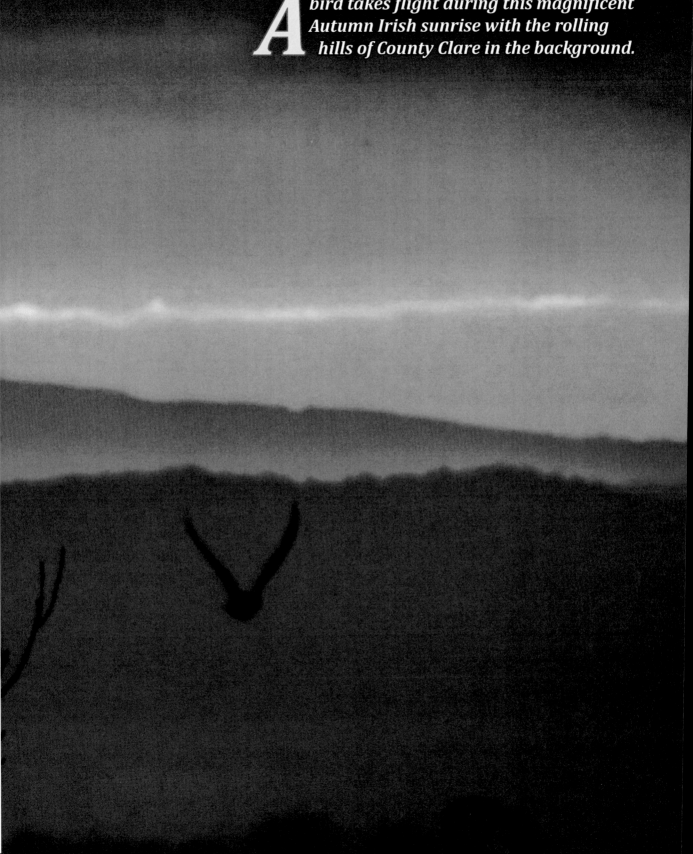

A bird takes flight during this magnificent Autumn Irish sunrise with the rolling hills of County Clare in the background.

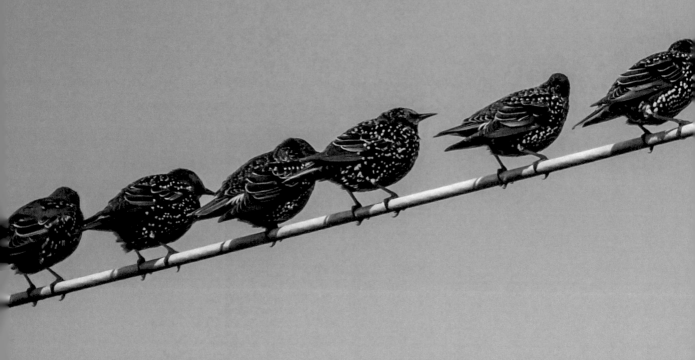

A *chorus line of Starlings await dusk from their perch on power lines over Lissycasey in County Clare.*

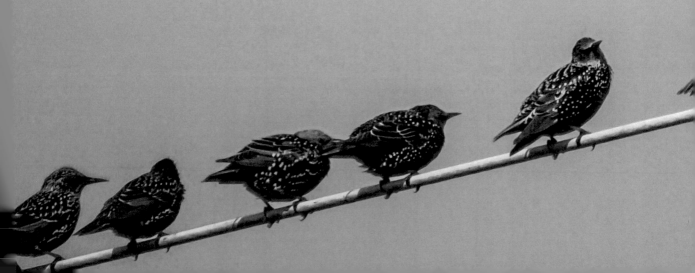

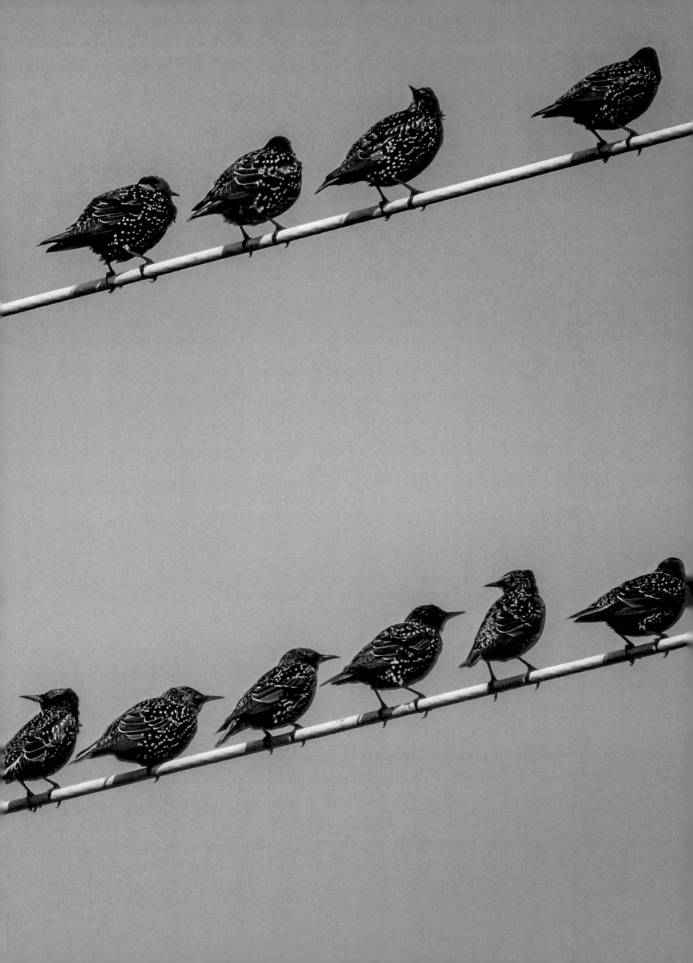

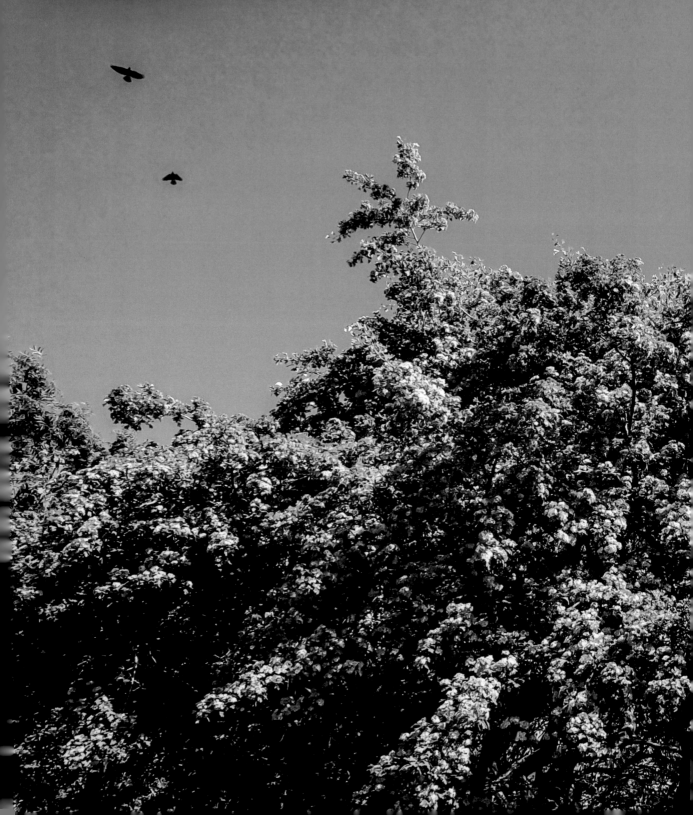

A flock of crows swarm around a white thorn tree flowering in the Irish Springtime.

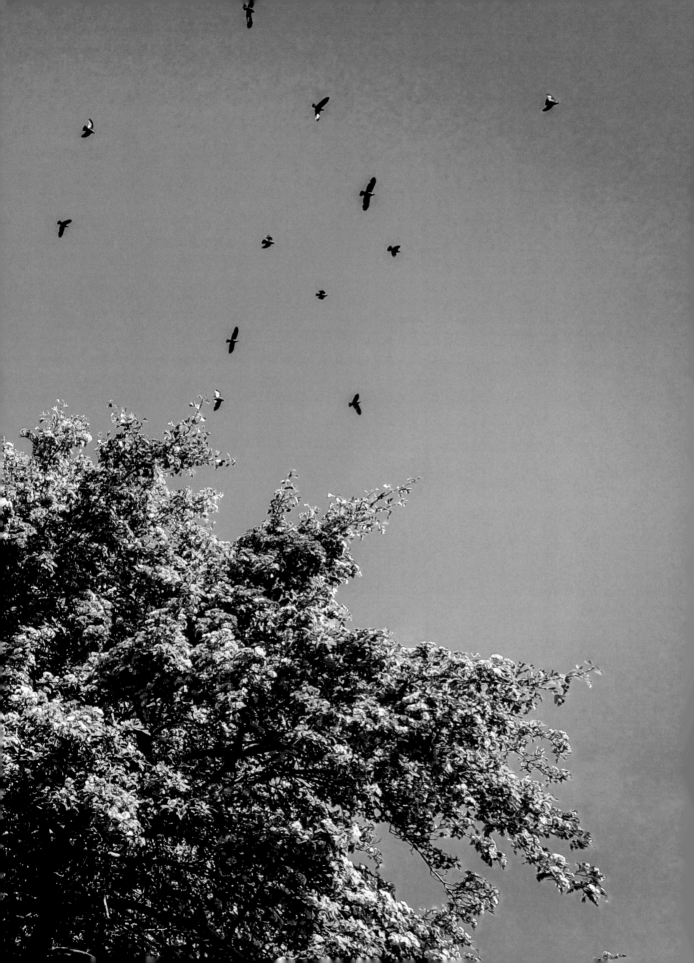

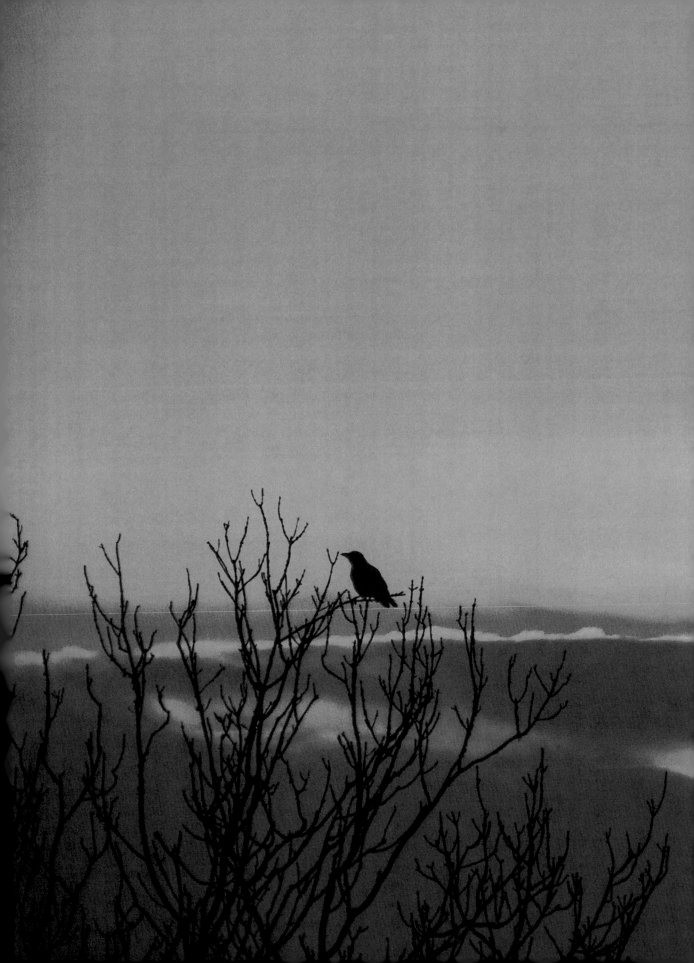

A solitary crow awaits the arrival of Spring during this early March sunrise over County Clare.

A mid-Autumn sunrise over Shannon Airport reflects on County Clare's Fergus River where it joins the Shannon Estuary.

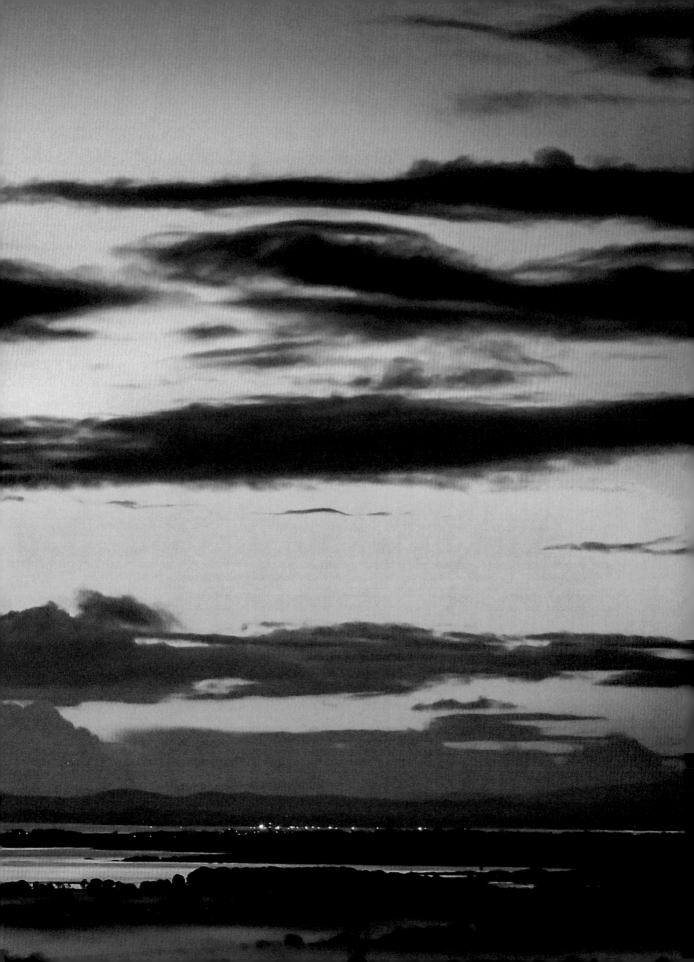

Morning clouds part to reveal a boiling red sunrise over the County Clare horizon near Ennis.

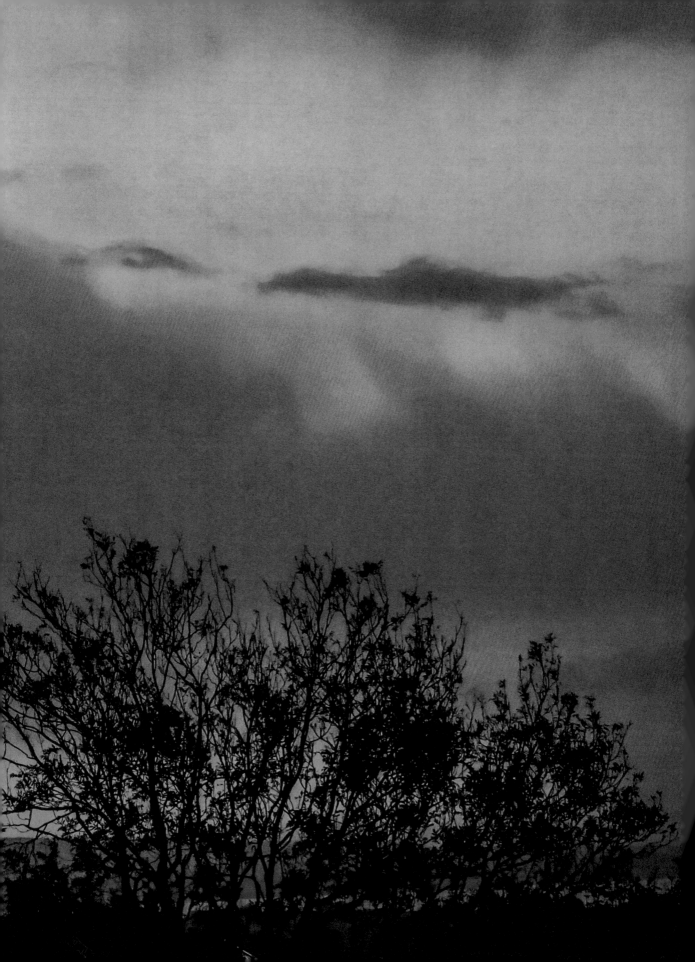

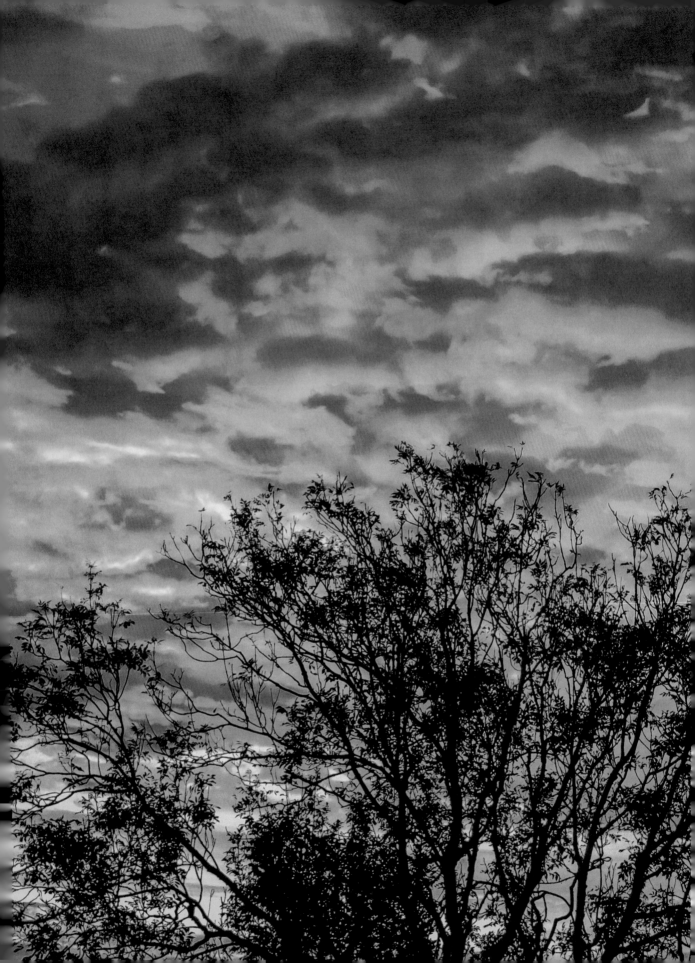

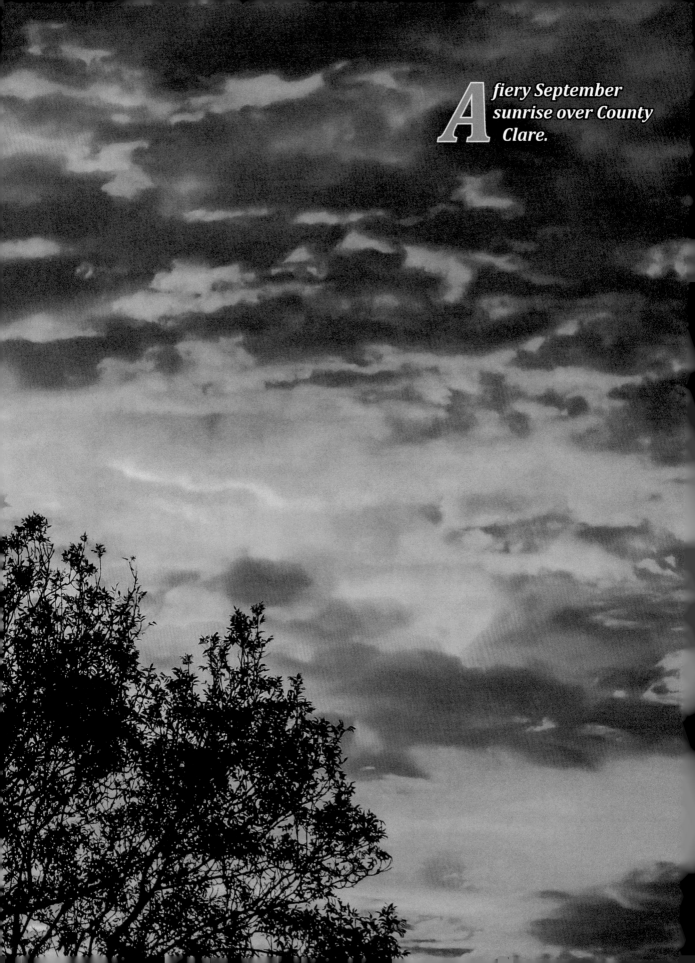

A fiery September sunrise over County Clare.

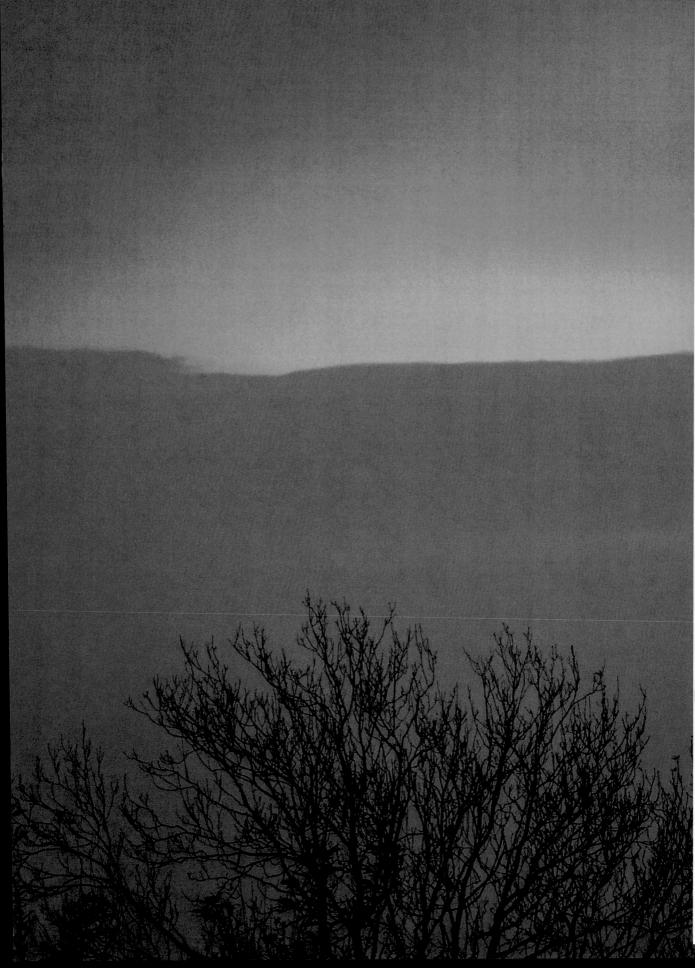

An Irish sunrise casts a luminous crimson glow on the clouds over a fog bank engulfing the Shannon River Estuary and surrounding valley in County Clare.

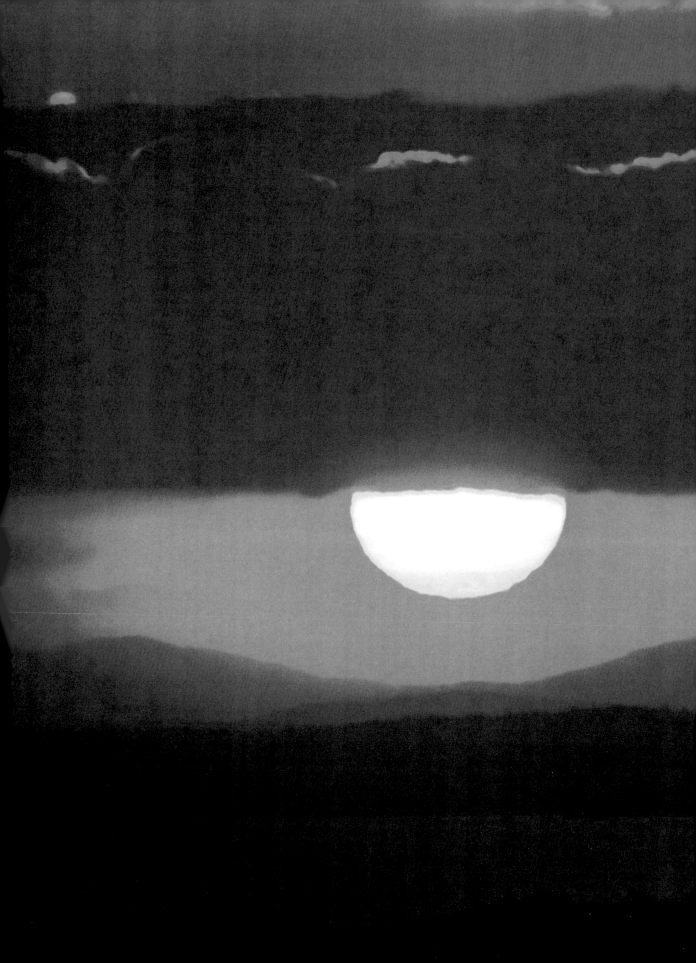

A Winter sun rises over the River Shannon, dividing counties Clare and Limerick.

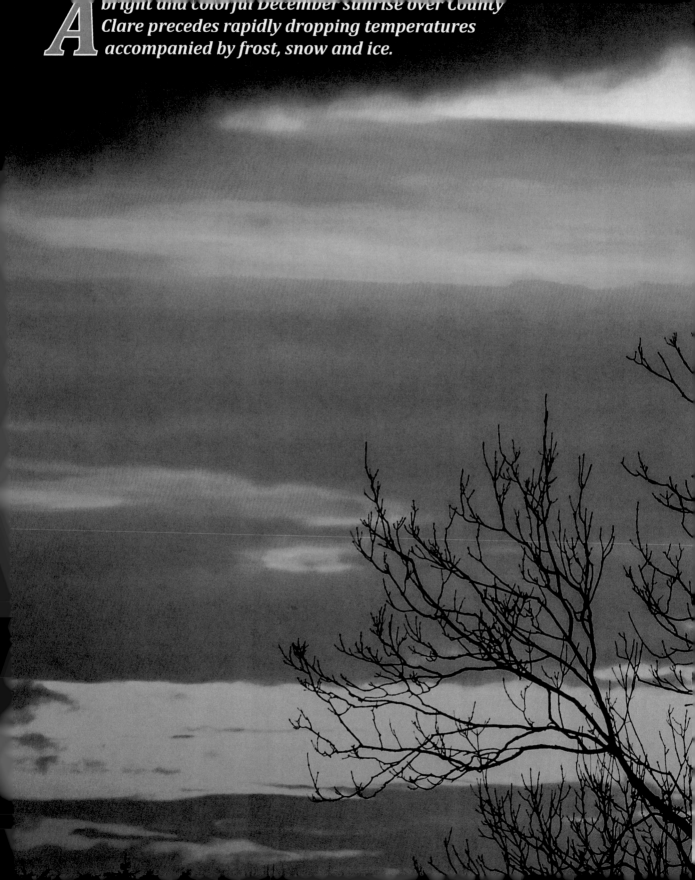

A bright and colorful December sunrise over County Clare precedes rapidly dropping temperatures accompanied by frost, snow and ice.

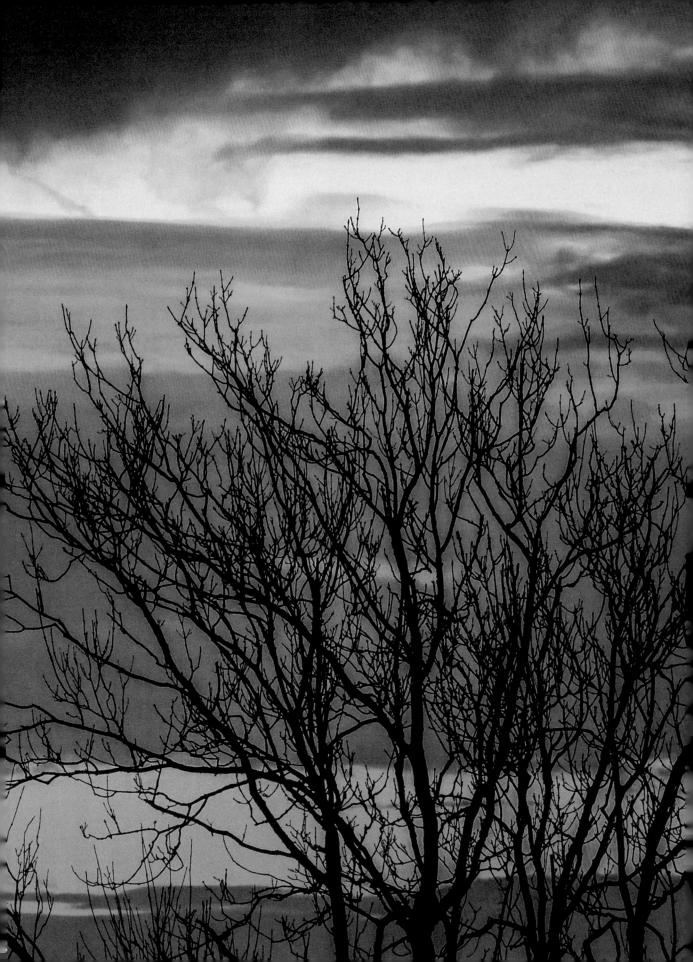

Crisp freezing temperatures make for an incredibly brilliant sunrise over the Shannon River Valley in County Clare.

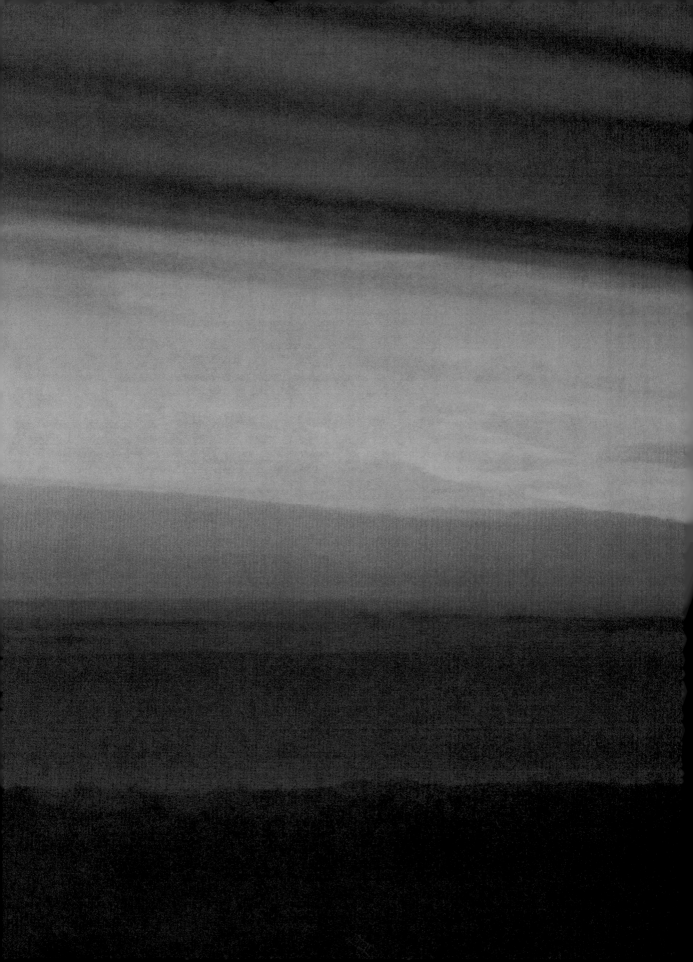

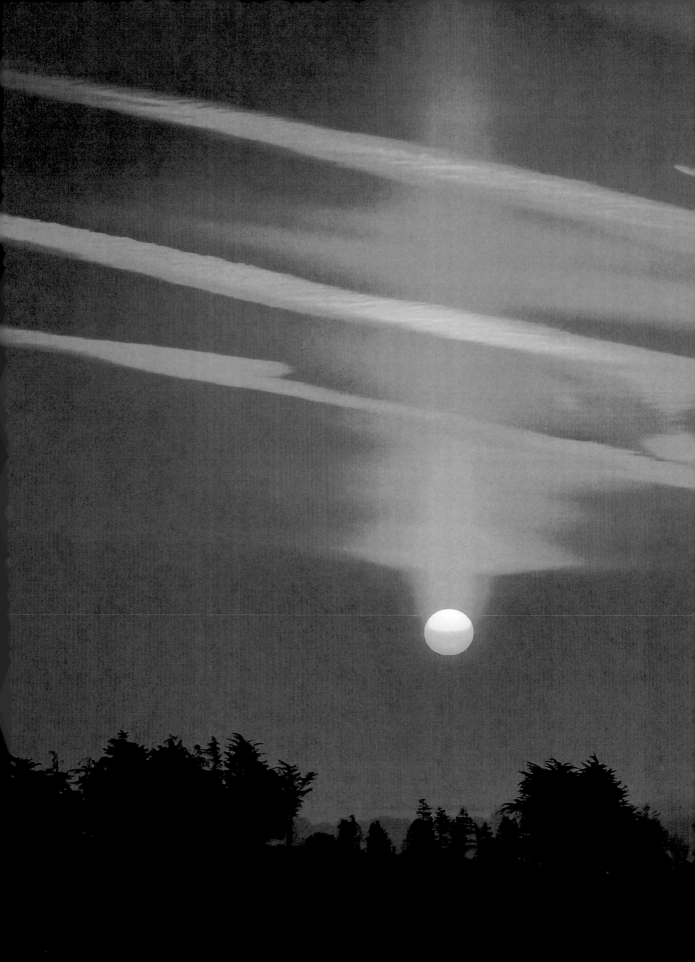

A unique pillar of light shoots skyward during this Spring sunrise over the County Clare countryside.

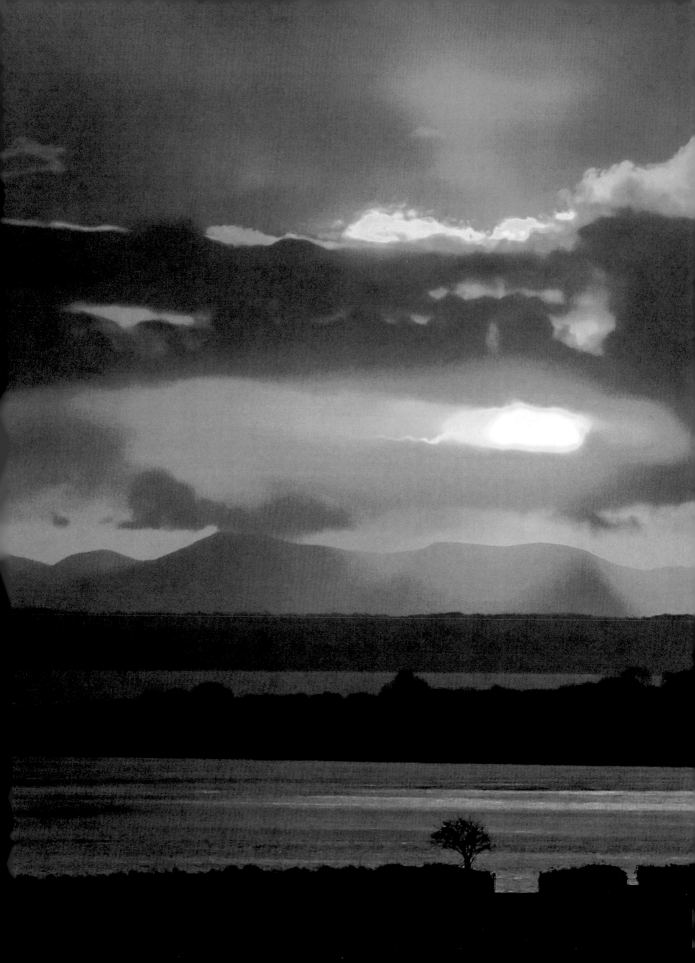

An Autumn sun rises over the Galtee Mountains and Shannon Estuary after a stormy night in Ireland.

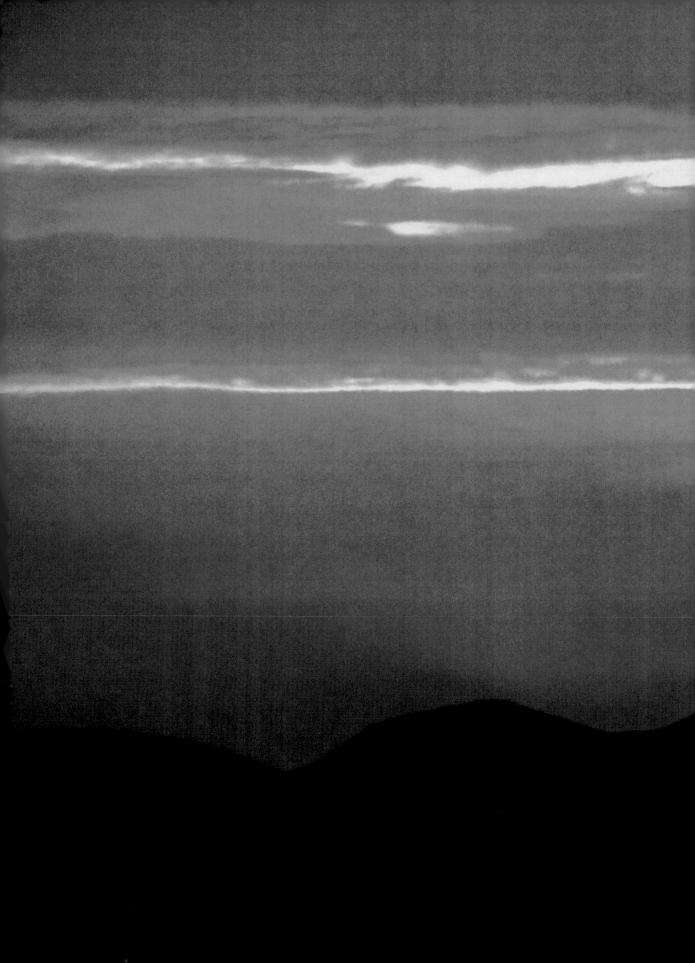

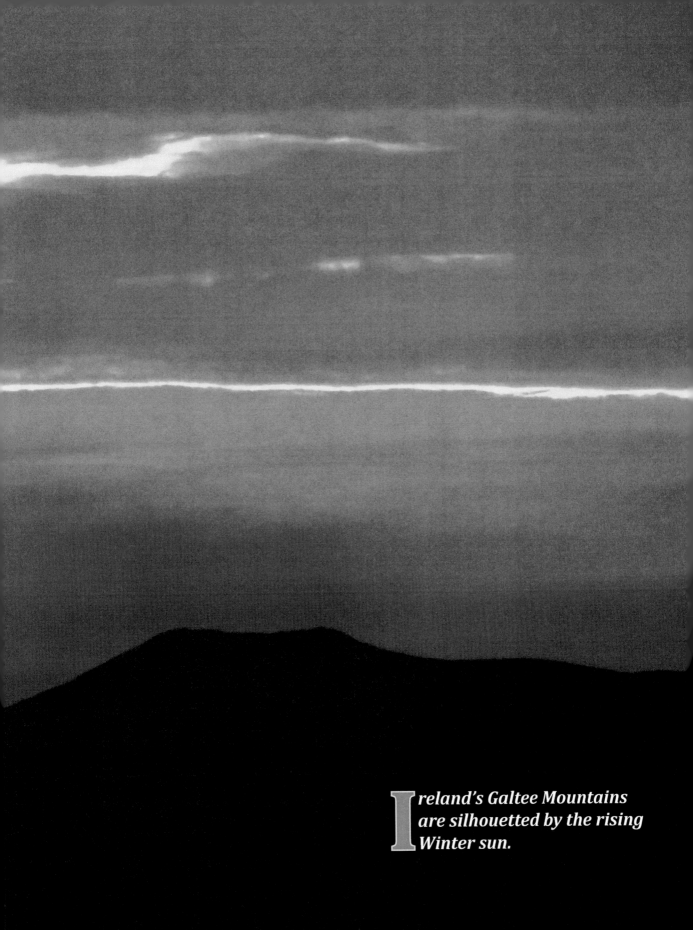

Ireland's Galtee Mountains are silhouetted by the rising Winter sun.

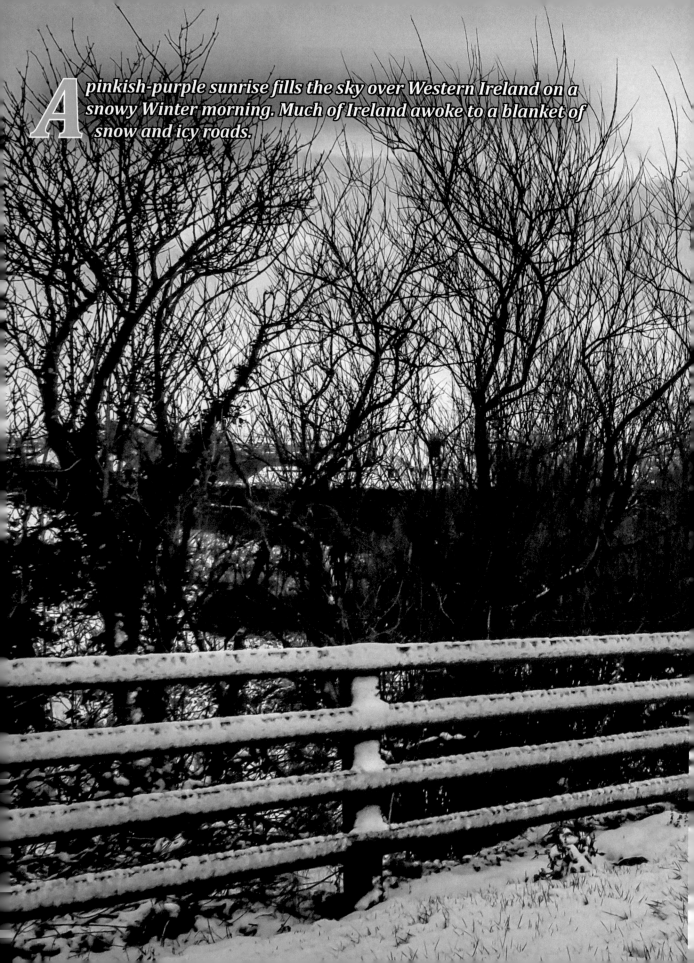

A pinkish-purple sunrise fills the sky over Western Ireland on a snowy Winter morning. Much of Ireland awoke to a blanket of snow and icy roads.

A crimson sunrise pierces the morning veil of Winter clouds over Ireland's Shannon Airport. In the foreground are the misty rolling green hills of County Clare and the River Fergus.

The Shannon Estuary, epicenter of transatlantic aviation history, is in the background, with the Galtee Mountains of counties Limerick and Tipperary beyond.

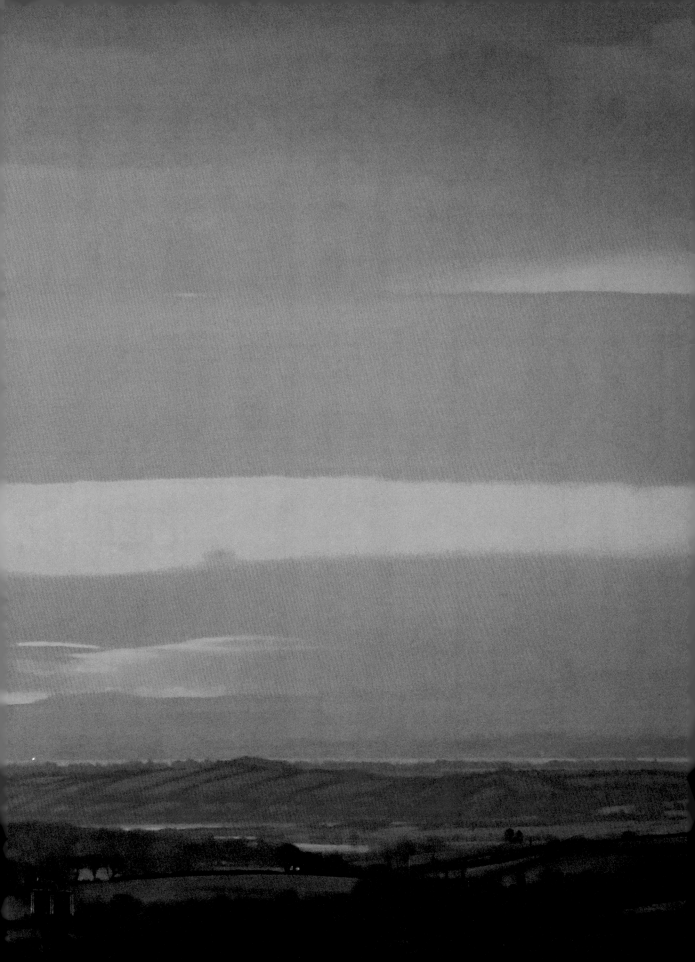

The lights of Ireland's Shannon International Airport (SNN) glow in the dawn sunrise. Imagine landing here to begin a tour of Ireland, bathed in the brilliant colors of a spectacular sunrise over the patchwork green meadows of the Irish countryside below.

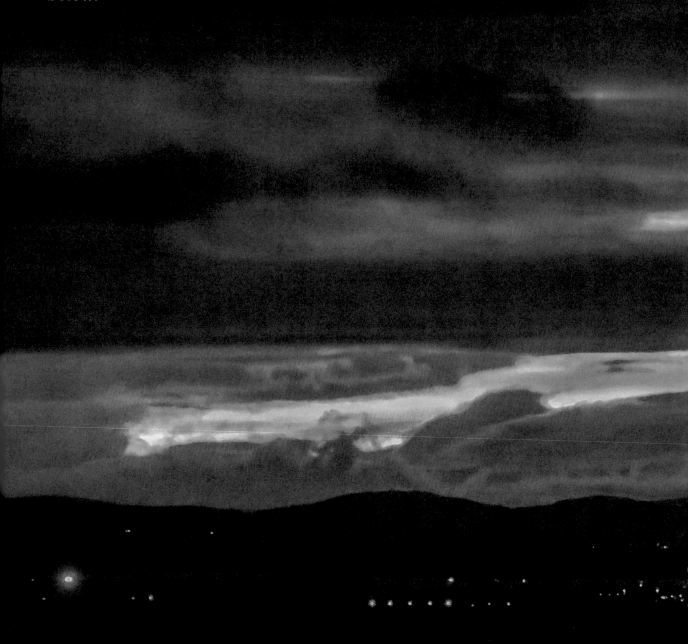

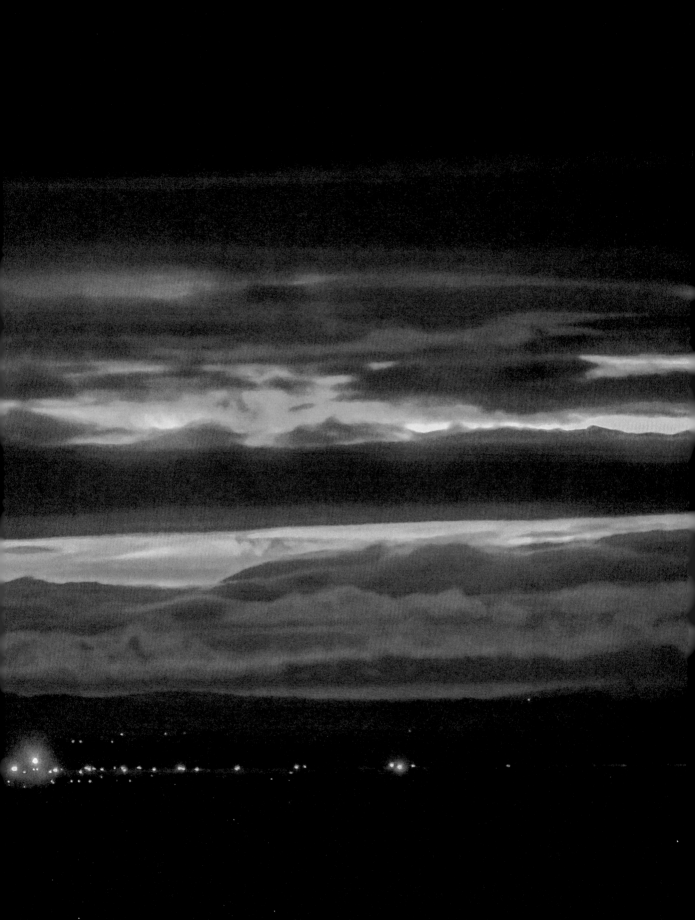

his citrus and crimson sunrise reflects in the waters of the River Fergus near Ennis in County Clare, just before the river empties into the Shannon Estuary for the journey out to the Atlantic Ocean.

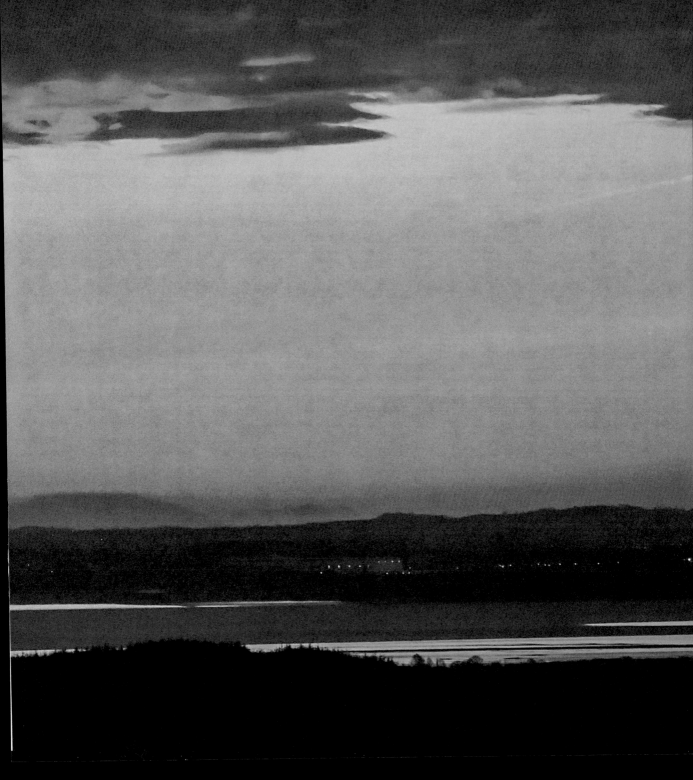

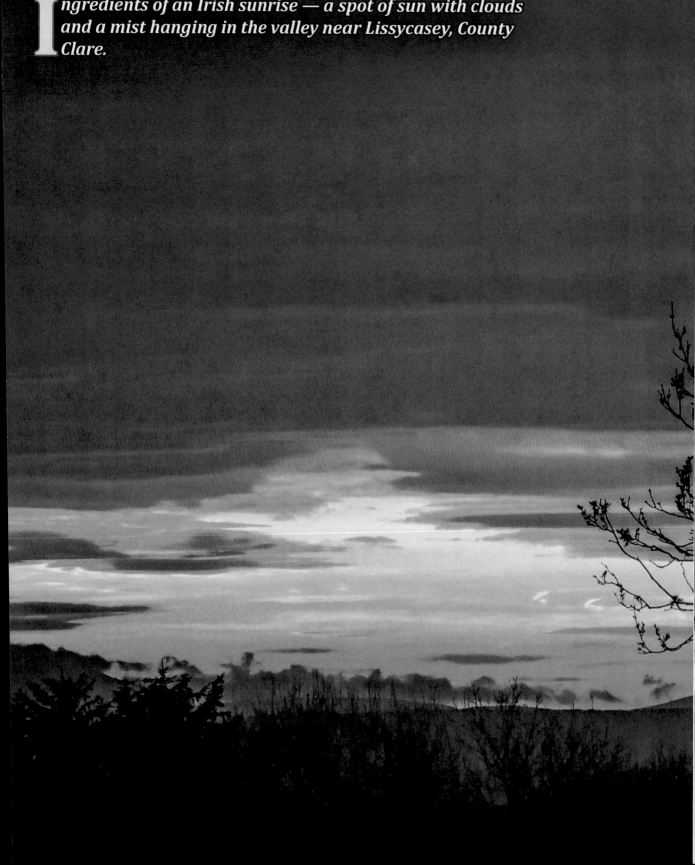

Ingredients of an Irish sunrise — a spot of sun with clouds and a mist hanging in the valley near Lissycasey, County Clare.

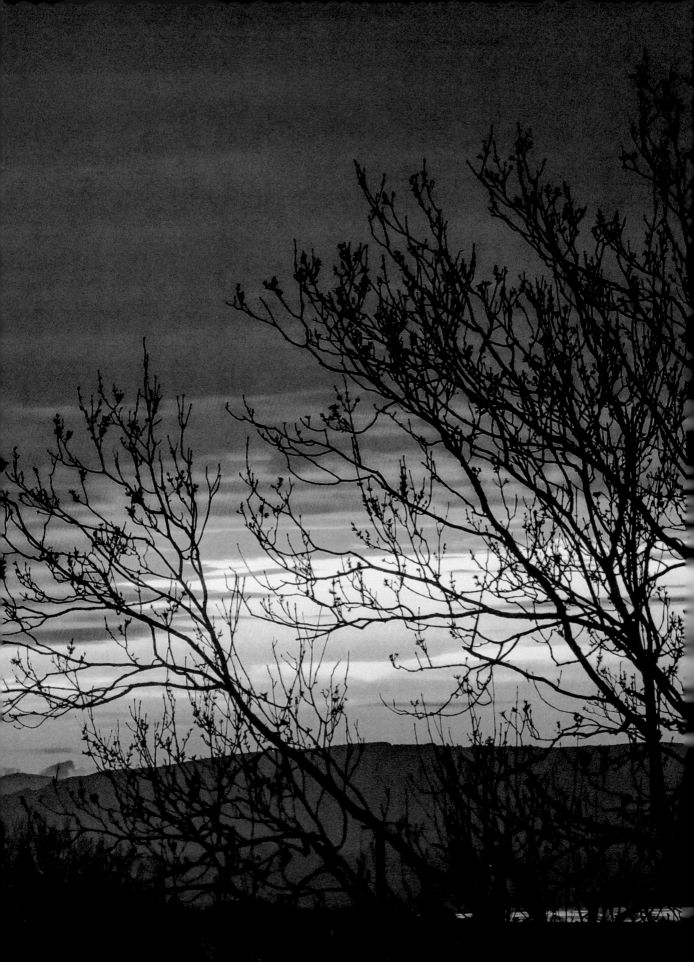

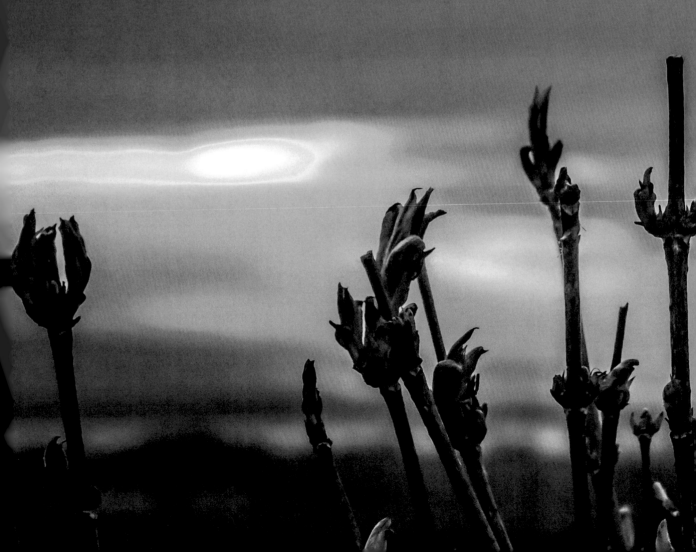

New Spring leaves sprout to the symphony of sunrise colors beaming over Ireland's River Fergus in County Clare.

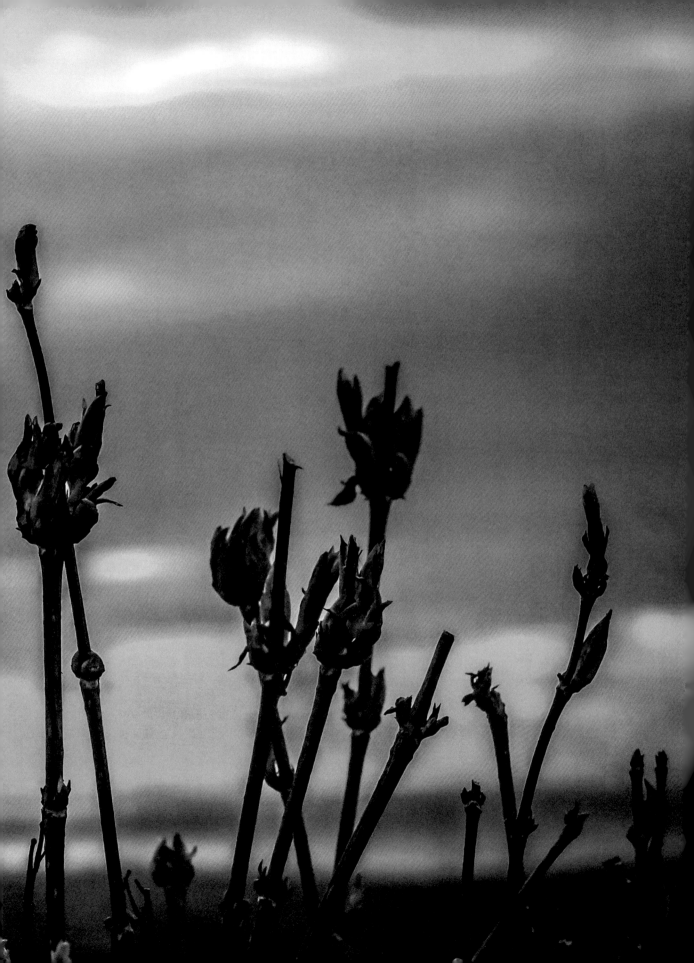

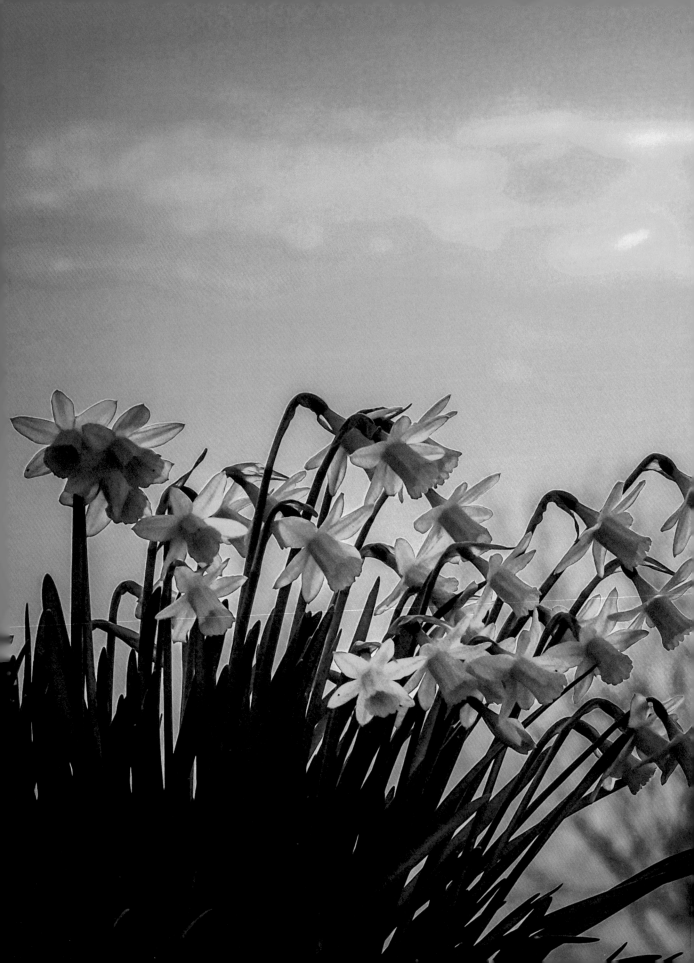

Daffodils reach for the rising Spring sun over County Clare.

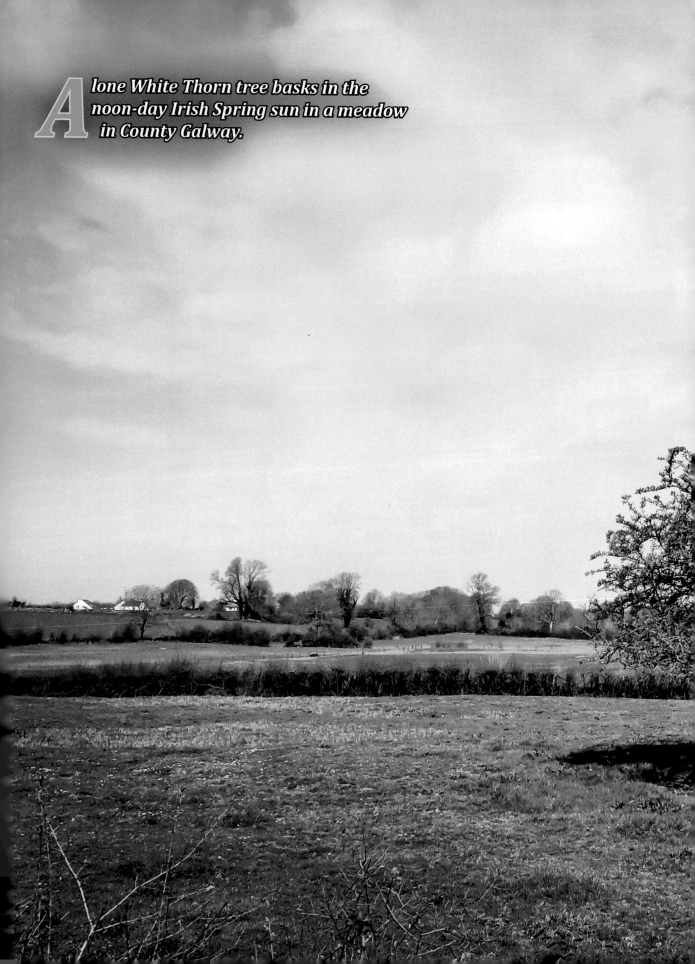

A lone White Thorn tree basks in the noon-day Irish Spring sun in a meadow in County Galway.

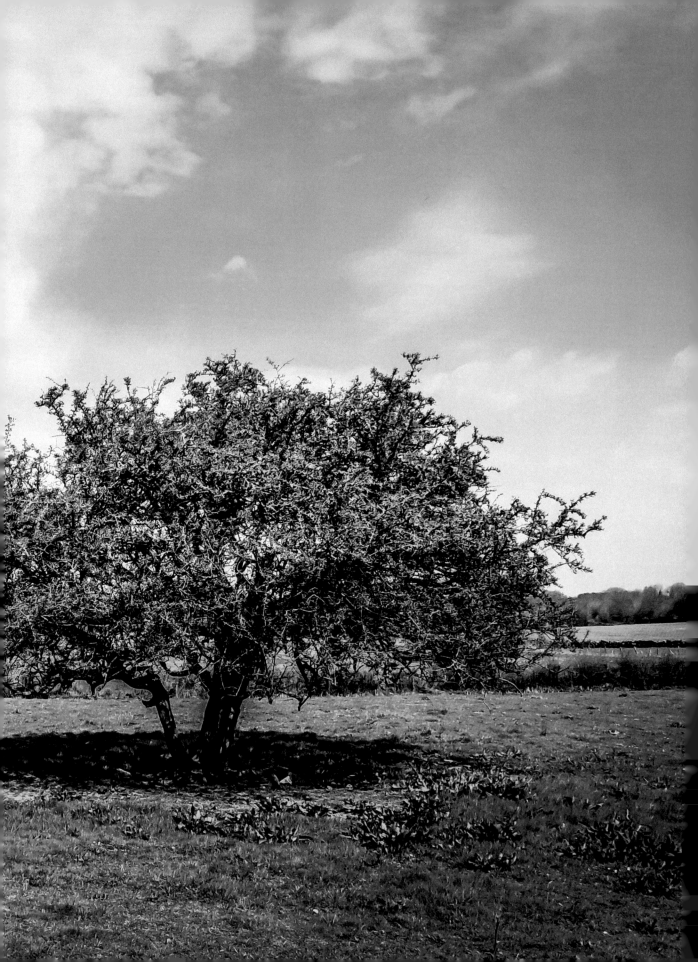

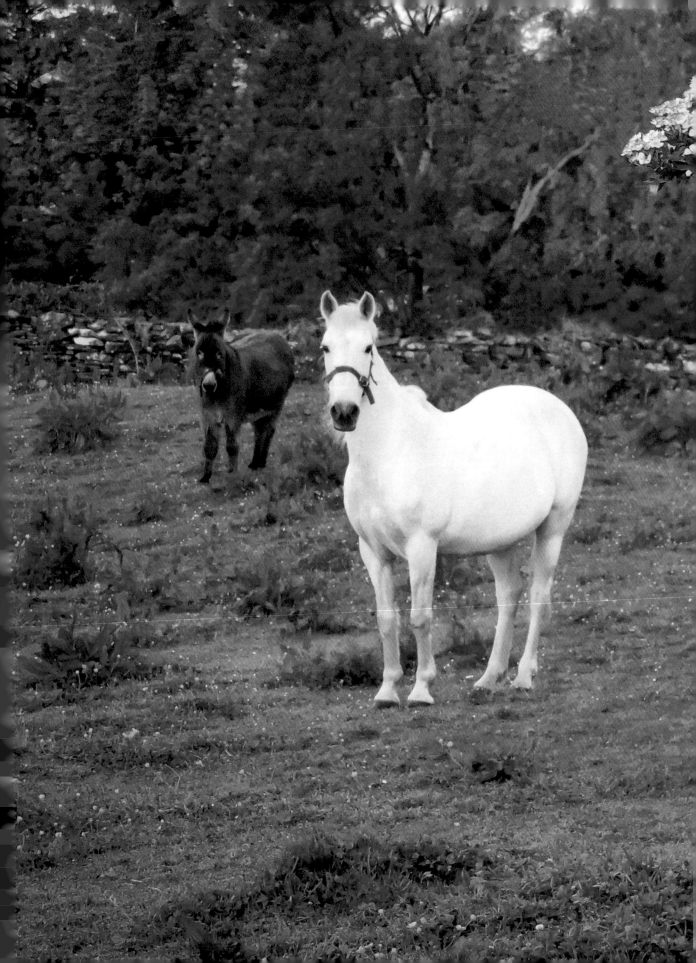

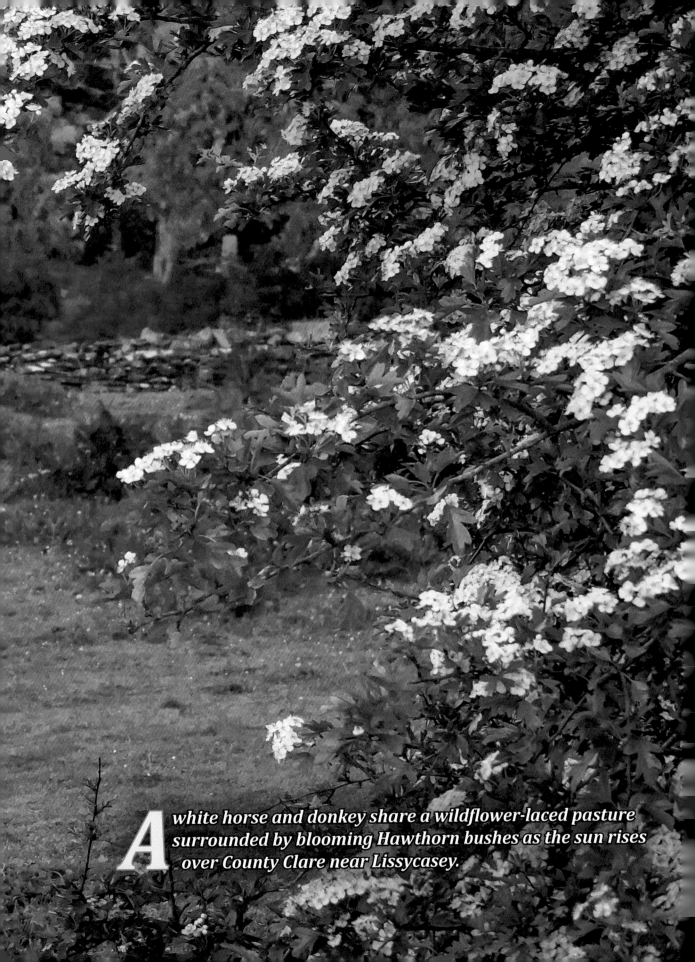

A white horse and donkey share a wildflower-laced pasture surrounded by blooming Hawthorn bushes as the sun rises over County Clare near Lissycasey.

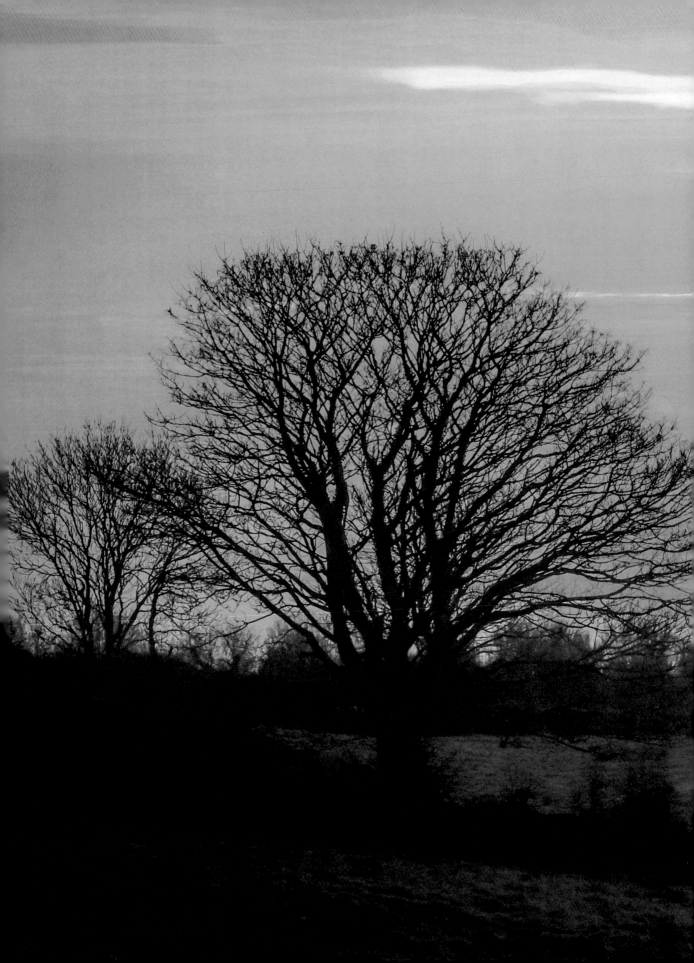

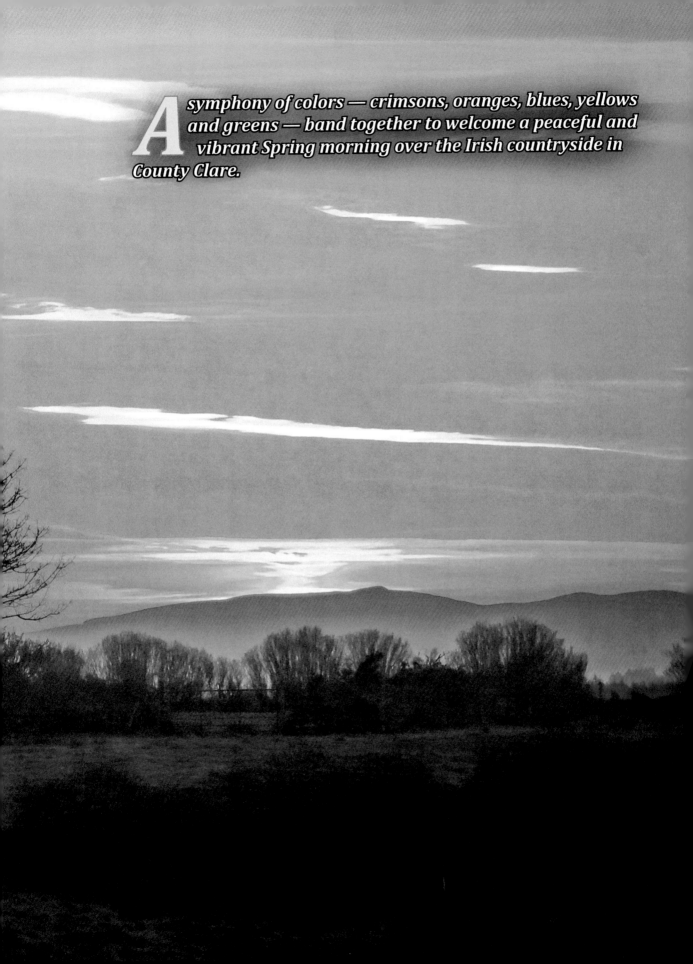

A symphony of colors — crimsons, oranges, blues, yellows and greens — band together to welcome a peaceful and vibrant Spring morning over the Irish countryside in County Clare.

A brilliant pink sun disc dominates the Autumn horizon in County Clare as a lone tree prepares for hibernation.

A giant sun disc rises above the clouds to grace Ireland's Shannon River Valley with rays of morning light.

Acknowledgements
With Gratitude

Any creative pursuit is born of the assorted influences and people we draw into our lives, gently sculpted by circumstance and sometimes more assertively chiseled by a stern "wakeup slap." My adventurous and unconventional life continues to be no exception. I want to offer my gratitude to the following people who helped make this project possible...

My mother, **Lois Murphy Truett**, for the countless hours she spent waiting for me outside the office of the *Fairbanks Daily News-Miner*, as I began my newspaper career...

My father, **Robert Cullinan Truett**, who in his late 60's, carved a darkroom for me out of the permafrost walls of our home's basement in Ester, Alaska...

My brother-in-law, **Bill Eklund**, who encouraged me to pursue photography by loaning me some of his cameras...

C.H. Darby, one of my early mentors, for teaching me about studio photography and darkroom techniques...

My Irish family and close friends, **Francis and Helen Murphy**, for sharing adventures with me and for our always enjoyable and soul-enhancing Saturday lunches...

My faithful housekeeper and friend, **Anne Fitzgerald**, whose steadfast support and no-nonsense advice are much appreciated...

My "little sister," **Bridget O'Sullivan**, whose creative genius and reasoned feedback are a genuine gift...

My "big sister," **Sue McGovern Downward**, whose encouragement has always kept me moving forward...

My son, **Alberto Truett**, for his never-ending excitement, his fresh outlook on life and his truly admirable determination. *Estoy muy orgulloso de ti...*

And finally, a special thanks to **Pat and Michelle McMahon** and **Robert McMahon** for the beautiful setting that feeds my creativity daily.

Other Books by James A. Truett

 Mystical Moods of Ireland - Vol. II:
Enchanted Celtic Skies

 Mystical Moods of Ireland - Vol. III:
Magical Irish Countryside

 Mystical Moods of Ireland - Vol. IV:
In the Footsteps of W. B. Yeats at Coole Park and Ballylee

 Mystical Moods of Ireland - Vol. V:
Book of Irish Blessings & Proverbs

Available through Amazon.Com and major booksellers:
www.JamesTruettBooks.Com

*Follow James A. Truett's adventures
and get free previews of his books here:*
www.JamesATruett.Com/subscribe

About James A. Truett

Photo by Susan Bowlus

Growing up in Alaska, near the quaint hamlet of Ester, near Fairbanks, James A. Truett developed an appreciation for nature as a child, exploring the majestic wilderness of his home state both on the ground and in the air.

He began his career as a journalist and photographer for the local newspaper at the age of 14, picked up his private pilot's license at the age of 17, and by the age of 19, he had moved to Seattle and joined The Associated Press, eventually becoming one of the youngest journalists in the world to be published in every major newspaper in the world.

Over the years, he developed an avid interest in sailing and traveled extensively by boat, auto and air in the U.S., Canada, Mexico, Central America, Ireland and the UK.

After tracing his ancestral roots back to Ireland and falling in love with the beauty of the Irish countryside, he settled in County Clare from where he manages his portfolio of art, photography and publishing projects.

Connect with James A. Truett on Social Media:
www.JamesATruett.Com/social

More kind words from Fans...

"James, thanks for sharing with everyone the enchanting pictures of Ireland!" ~ **Anita Sims**

"Your pics are amazing. Thank you for sharing lovely Ireland with us." ~ **Wendy Parker Foster**

"We look forward to all your pictures, They bring a smile to our lives." ~ **Theresa O' Brien**

"I always love your photos of Ireland and your narratives, James! Lovely, serene place! I could use a place like this now, Ha Ha. Beautiful!" ~ **Margaret McClanahan**

"May God bless you with much health and happiness. You do bring joy to people with the beauty of God's land."
~ **Margie Fleischmann**

"James, your photos only make me more homesick for Ireland and that's a fact. I truly love your photos. Although I was not born in Ireland, I feel as if it is Ireland that is my home. Each time I have been to Ireland, I have felt like I was returning home and always, I mean always, a sadness would engulf me at the very thought of leaving Ireland to return to the States."
~ **Sandie Pickard**

"Your photography is amazing.....but this.....is simply stunning. Absolutely beautiful! Your artistry abounds." ~ **Dayna Fesciuc**

"So many beautiful places in Ireland to be at peace with nature, forgetting the "rat race" best therapy I find. Your photos are lovely." ~ **Eileen Hassard**

"Oh James, what a beautiful picture. Looks so calm and serene. Wish I could sit there for a while and ponder the beauty of the flowers. You always find the most beautiful things to post. I am so grateful you're there to do that for me as well as the world. Have a great week!"
~ **Maureen C. Stamper**

"Stunning sunrise, beautiful picture, good information. Your talent shines, James. Your posts always give me a lift in spirit." ~ **Pat Erskine**

"What a peaceful picture. The new book is wonderful." ~ **Allison Elliott**

"Mystical vision... thank you Mr. Truett !!" ~ **Linda Haggerty Walters Thompson**

"I love it, now I can sit at home and pretend I'm in Ireland. Maybe some day I can see them all in person! Beautiful work!" ~ **Heather Casey**

"Beautiful picture! Very serene. Thank you for sharing." ~ **Pam Harley Calkins**

"Beautiful! Thanks for all your lovely pictures!" ~ **Patricia Brennan**

"Thank you for sharing all your beautiful work." **~ Gail Durham**

"I so look forward to your posts, I look into your pictures and find that few minutes of peace and serenity each day. I thank you so much, you are a very bright spot in a very complicated world." **~ Sandra Morrison**

"I have written a review of your most exquisite array of photographs on Amazon. I am so glad that I happened upon your work. It is a beautiful and magical display of the Irish countryside. I plan on adding your complete collection to my library! Thank you for sharing the beauty that is Ireland and your wonderful talent with the world! I am a forever fan!!" **~ Marianne Moore**

"Well well done James A. Truett. Fantastic work you do." **~ Ireland of a Thousand Welcomes**

"Thank you James for sharing all your wonderful photographs." **~ Anne Kelly**

"Wouldn't miss it for the world. You take me places I've always wanted to go. You make my dreams come true. Thank you, James." **~ Cheryl Phillips**

"Congratulations and Thanks for sharing all the beauty of such a beautiful country!! Love looking at all the photos!!!" **~ Yvonne Mae**

"Wonderful James, enjoy your talent, thanks for sharing." **~ Hilary Fitzpatrick**

"Congratulations! Your posts keep me going until I get to come visit your beautiful country!" **~ Debbie Wagstaff**

"Your photos are like seeing poetry in living color..." **~ Candy Hardin**

"Thank you for sharing all the beauty you capture in your wonderful pictures. The stories are such a bonus, too." **~ Rusty Brennan**

"Thank you, James. Positive wishes to you in every endeavor. Your work brings such beauty to the lives of others." **~ Vivienne Nichols**

"Absolutely lovely. You have a true artists' eye, James ." **~ Mary O'Neill**

" Absolutely beautiful... and you've got me singing again, James. Fab picture. " **~ Christine Shaughnessy**

"Thank you for sharing Ireland with us!!" **~ Beverly Venable**

"James, I hope you know how much we look forward to your photos always making your fans see the beauty that we so appreciate from afar... thank you so much." **~ Toni Walter Rao**

"Beautiful. I enjoy your history that goes with the pictures." **~ Jane Cates**

"Beautiful, love your pictures, they make me wish I was there. Thank you." **~ Joy Furister**

" I love each and every picture you share. Look forward to meeting with you when we come to the Emerald Isle." **~ Charlene Kunold McCarthy**

"Love your pictures" **~ Verna Livingston**

Irish Blessing

"May flowers always line your path
and sunshine light your day.
May songbirds serenade you
every step along the way.
May a rainbow run beside you
in a sky that's always blue.
And may happiness fill your heart each day
your whole life through."

JAMES A. TRUETT

Journalist • Author • Photographer • Artist

www.jamesatruett.com

Made in the USA
San Bernardino, CA
17 September 2018